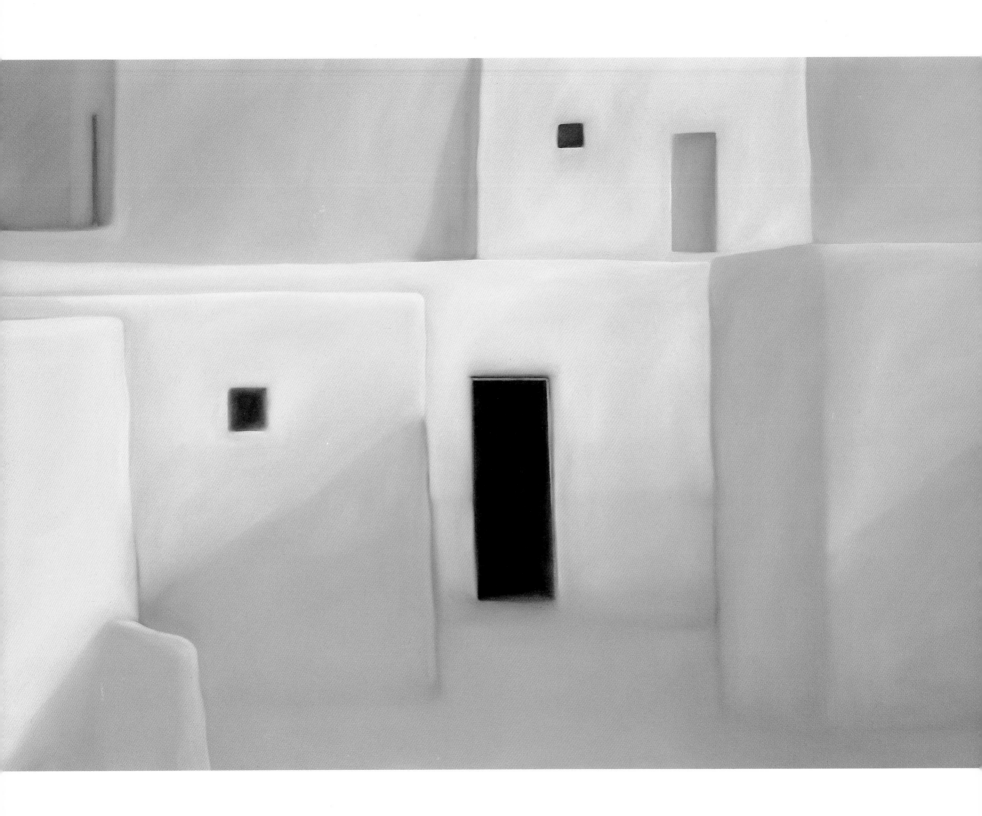

JOHN AXTON

By Linda Grace

Copyright © 1989 by John Axton
All rights reserved
Printed in Japan
Design and production by Natalia Nadraga

Library of Congress Cataloging-in-Publication Data
Grace, Linda,
 John Axton / by Linda Grace.
 p. cm.
 1. Axton, John—Catalogs. 2. New Mexico in art. I. Title.
N6537. A96A4 1989
760′.092′4—dc19 88-38641
ISBN 0-8093-1558-0 CIP

Acknowledgments

The following persons deserve special recognition for
their research and technical assistance: Connie Axton,
Margaret Parks, Sara McRee, John Richardson, Art
Gore, Dr. Marvin C. Overton III, William Stennis,
M.D., John Szoke, and J. Gary May, M.D. Our thanks
to photographers Herbert Lotz, Michael Tincher, and
Claudia Hose, whose work helped to make this book
a reality. Finally, we wish to express our appreciation
to Ventana Fine Art, Santa Fe, New Mexico;
Breckenridge Galleries, Breckenridge, Colorado;
Kauffman Gallery, Houston, Texas; and Western
Images, New York City, New York.

Frontispiece: Drum Maker, oil, 1984.
Collection of Martha Wallis.

Published for The John Axton Institute
Southern Illinois University Foundation

Southern Illinois University Press
Carbondale and Edwardsville

To the Faculty of the College of Technical Careers,
for their commitment to excellence in education.

List of Plates

The Artist

"To know my work is to know me." Art is John Axton's means of communicating with the world, of expressing his personal philosophy. The artworks chronologically presented in this book, a representative selection of Axton's finest oils, acrylics, and lithographs completed within the past fifteen years, give the reader a better understanding of the Santa Fe artist.

Axton was born in Princeton, Indiana, on March 20, 1947. The death of his career-soldier father early in the Korean War affected him deeply. Axton spent much of his youth yearning for his father's return, a sense of loss that has remained with him into adulthood and that finds expression in his art today. Axton's high school years in Jacksonville, Illinois, were a period of self-searching. By the end of his junior year, he had completed all of the courses in drafting and architecture offered by his school, but had no intention of pursuing either profession. He enrolled in his first art class during his senior year and decided then to pursue a career in commercial art.

In 1965, Axton entered the Commercial Art program of the Vocational-Technical Institute (now the Commercial Graphics-Design program of the College of Technical Careers) at Southern Illinois University at Carbondale. Of the thirty-six students who began the intense and rigorous program that year, only 18 graduated—one of whom was Axton. While a student at SIU-C, Axton developed the skills, discipline, and perseverance that were to become the foundation of his artistic accomplishments.

Following graduation from college in 1967, Axton made a living as a commercial artist working for clients as diverse as the Mobil Chemical Corporation and the Illinois State Museum. He found that creating works according to criteria established by his employers left him unfulfilled and dissatisfied. Axton resolved his artistic frustration by spending his leisure time experimenting with a wide range of media, from abstract painting to collage. Though still dependent on his commercial work to survive, in 1970 he began to sell his artworks in sidewalk and mall art shows.

Confronted yet again with the uncertainty of existence—this time by the death at a young age of a close friend—Axton decided in 1976 to abandon altogether the security offered by commercial art for the personal autonomy of the studio artist. He moved to New Mexico in 1979, where he has resided ever since, and finds

freedom of expression and inspiration in the Taos Indian culture and the Southwest environment.

His deep admiration for the simplicity of Taos life comes through today as a mystical quality in his paintings, which some have called "spiritual," "haunting," and "visually elegant." His works evoke a wide range of emotions in viewers because he conveys only the essential elements of his subjects. The diminishing doorways and fading paths in his paintings invite access into Axton's world, and many viewers find the invitation to enter to be a compelling one.

Axton's artistic contributions were publicly recognized by his alma mater in May 1988 when the College of Technical Careers awarded him its Alumni Achievement Award for outstanding professional achievement and commitment to the College. In his acceptance speech, Axton shared his feelings about the path he has taken:

I have returned to the birthplace of my knowledge, to be embraced in the arms of my fostering mother with love and understanding, with an enthusiasm that has ignited a glow of contentment within me that few mortal beings will ever know.

I stand before you, not as an example of advice, but as an example of hope—as a paradigm for dreams dreamt, dreams pursued, and dreams achieved.

It is with a sense of conviction that I journey on Robert Frost's proverbial road less traveled. A personal courage that was first nourished by this institution has been the fulcrum upon which the levers of my success have rested.

With an overt willingness I have bared my soul to the world. My paintings are my journals; to know my paintings is to know me. To paraphrase Ralph Waldo Emerson, "Do your work, and I shall know you. Do your work and you shall know yourself."

When we realize that life is circular, that all things in God's universe share the same breath, then we can understand that the goal is not at the end of the road. The goal is the road.

To help others who wish to pursue careers in art, Axton has established an endowment fund for The John Axton Institute for talented high school students. Proceeds from the sale of this book will help support the endowment fund and the Institute's activities.

Plate 1

Close to Winter (1974)

Acrylic, 18″ × 30″, collection of
Tracie and Dean Curry

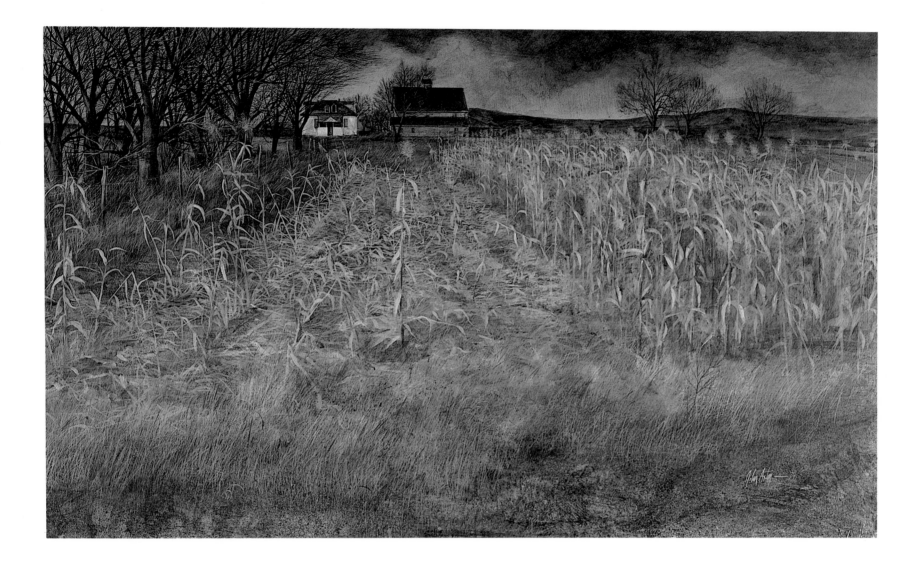

Plate 2

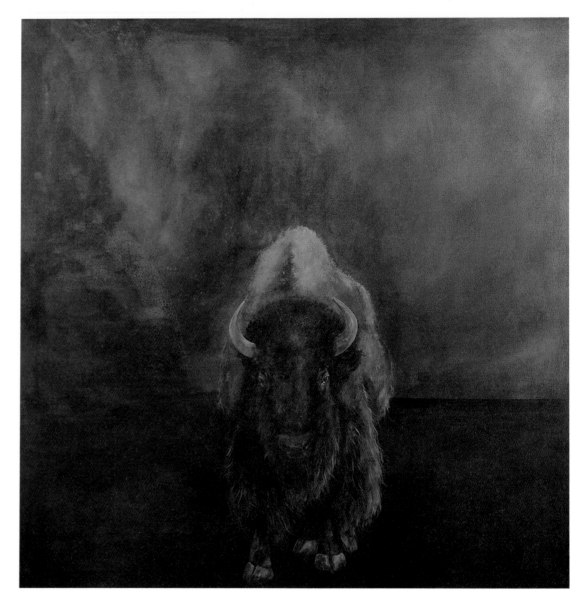

The American (1978)

Acrylic, 40″ × 40″, collection of Century Bank,
Cherry Creek, Denver

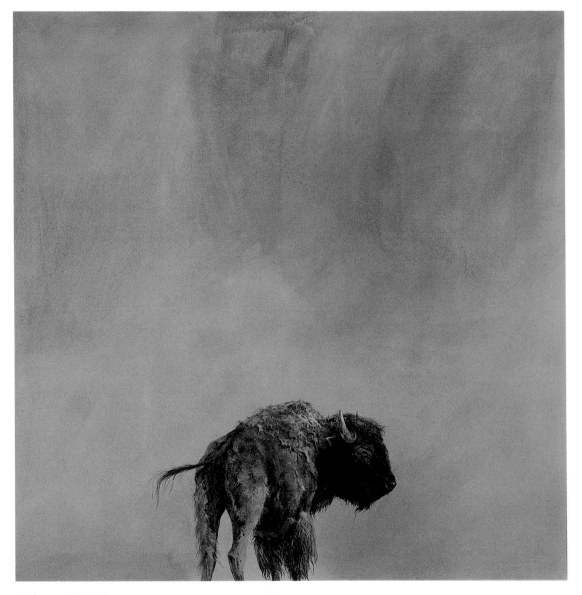

Plate 3

Refugee (1979)

Acrylic, 40″ × 40″, collection of
Marcia and Howard Potter

Plate 4

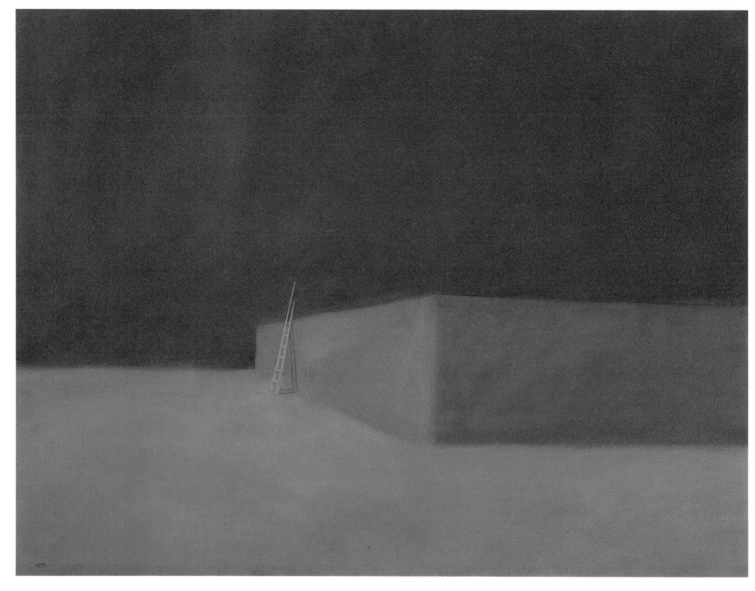

Taos Ladder II (1982)

Oil, 20″ × 30″, collection of
Thelma Walenrod

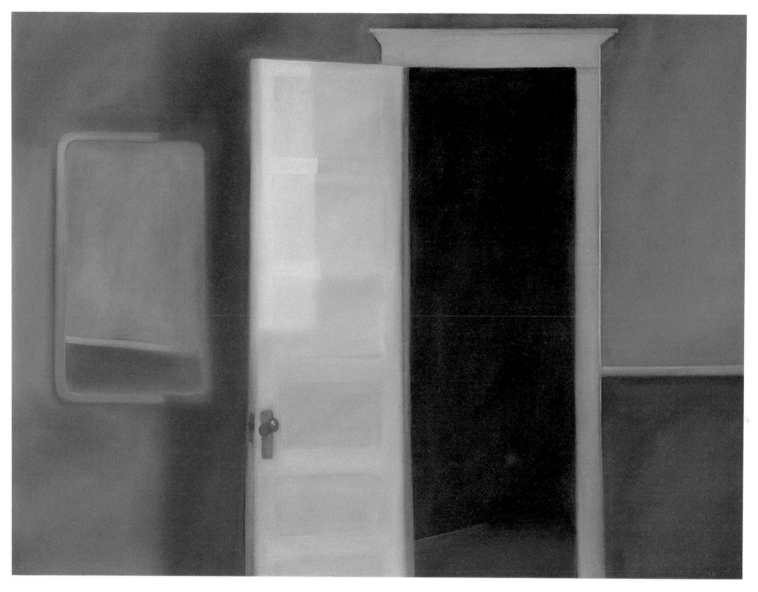

Plate 5

Room Full of Clues (1982)

Oil, 30″ × 40″, collection of
Ventana Fine Art

Plate 6

Pueblo Walls (1983)

Oil, 20″ × 30″, collection of Mr. and
Mrs. James D. Parks

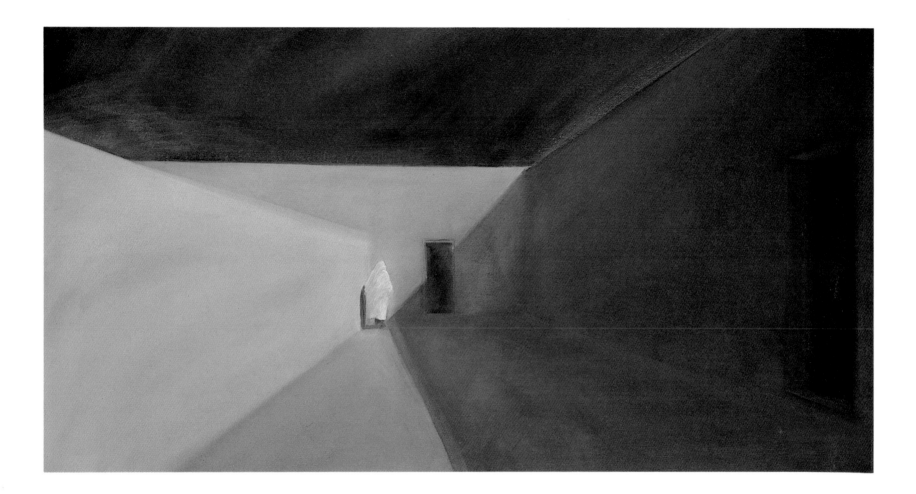

Plate 7

San Ildefonso Kiva (1983)

Oil, 30″ × 40″, collection of estate of Mamie Toll

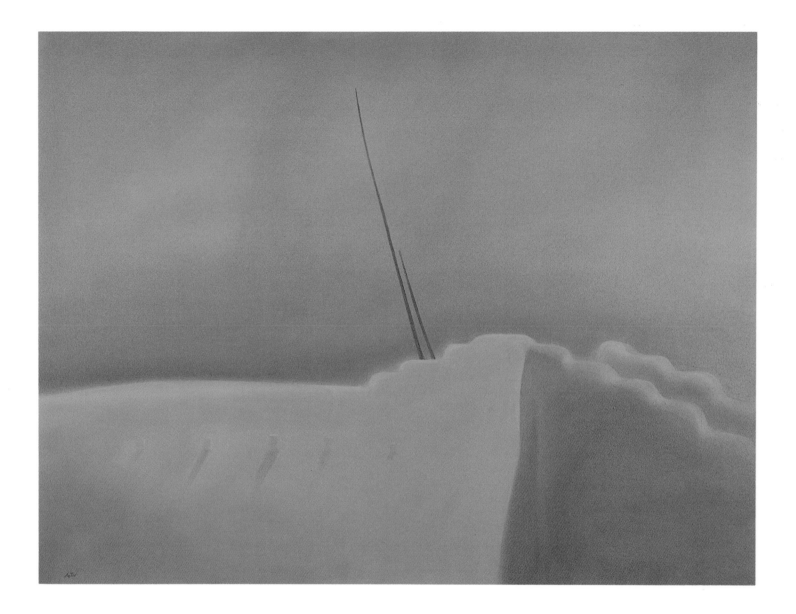

Plate 8

Talpa Morada (1984)

Oil, 20″ × 30″, collection of
Bobbie Allen

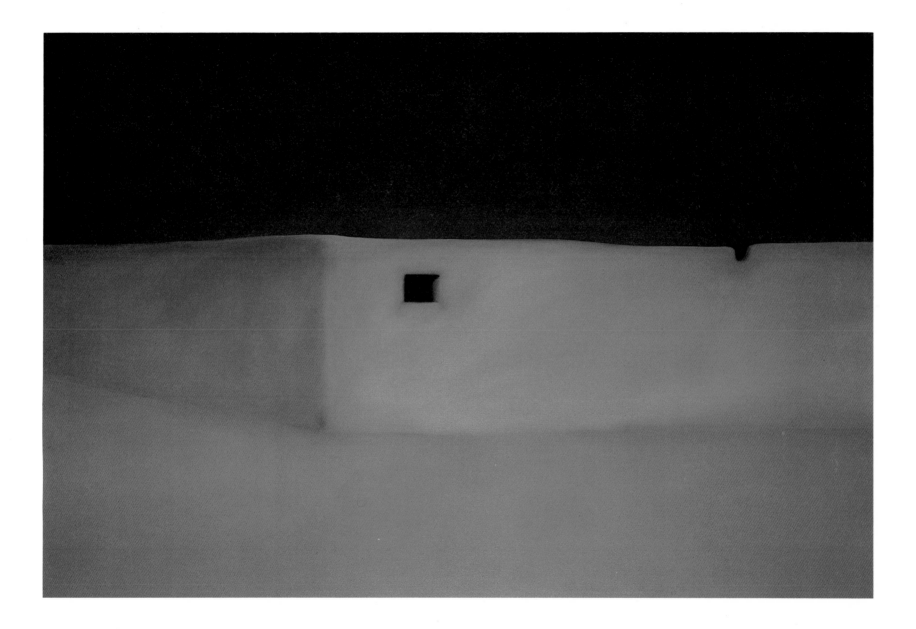

Plate 9

*Mora River, Overton Ranch,
Waltrous, New Mexico (1984)*

Oil, 12″ × 16″, collection of
Thelma Walenrod

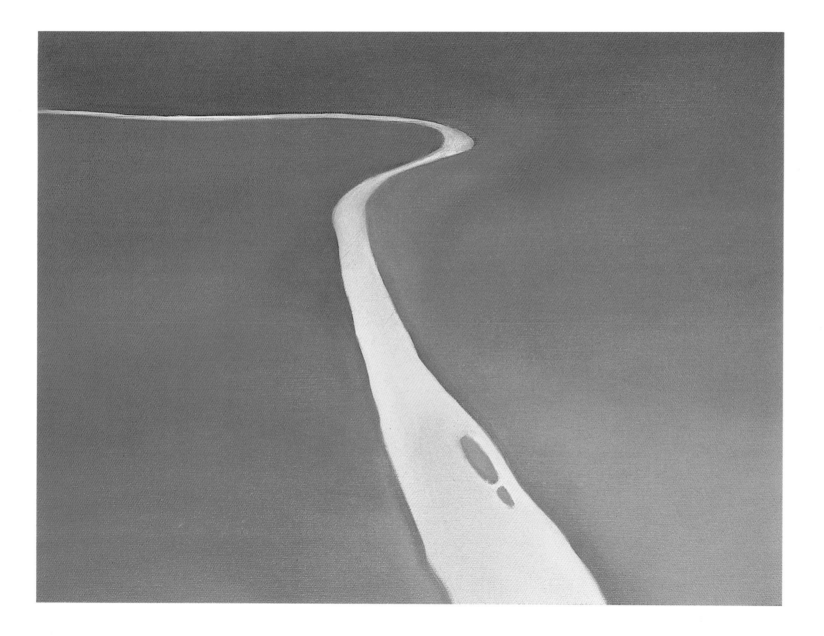

Plate 10

Canyon Storm (1984)

Oil, 40″ × 60″, collection of
estate of Mamie Toll

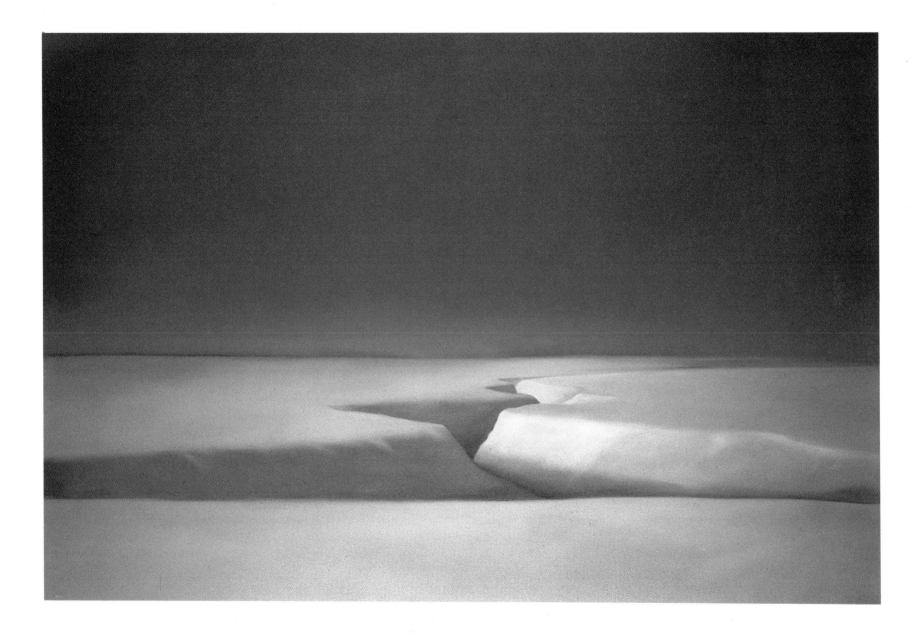

Plate 11

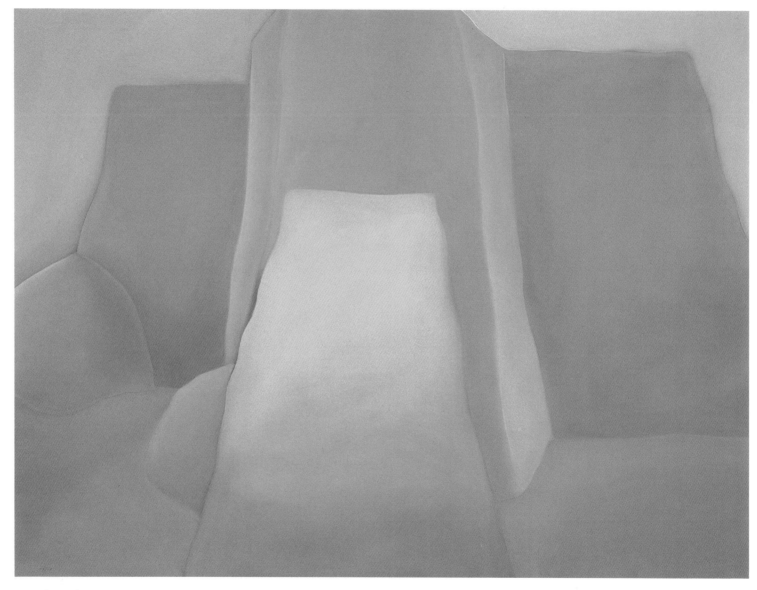

Ranchos de Taos (1984)

Oil, 30″ × 40″, collection of
Brian Interland

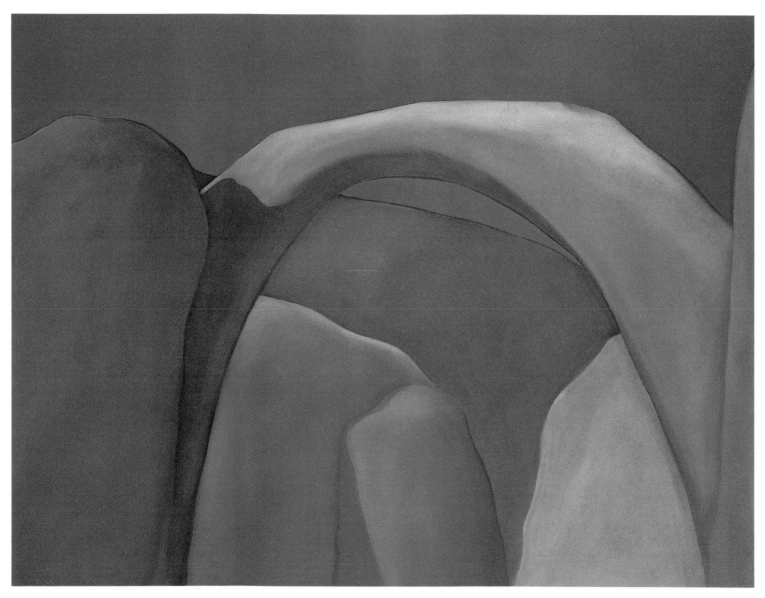

Plate 12

Rainbow Bridge (1984)

Oil, 30″ × 40″, collection of Bill
and Elaine Royer

Plate 13

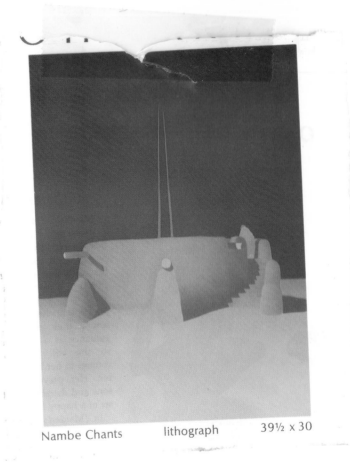

Nambe Chants lithograph 39½ x 30

San Ildefonso Kiva (1984)

Oil, 40″ × 60″, collection of Jerry
and Carol Ann Brantley

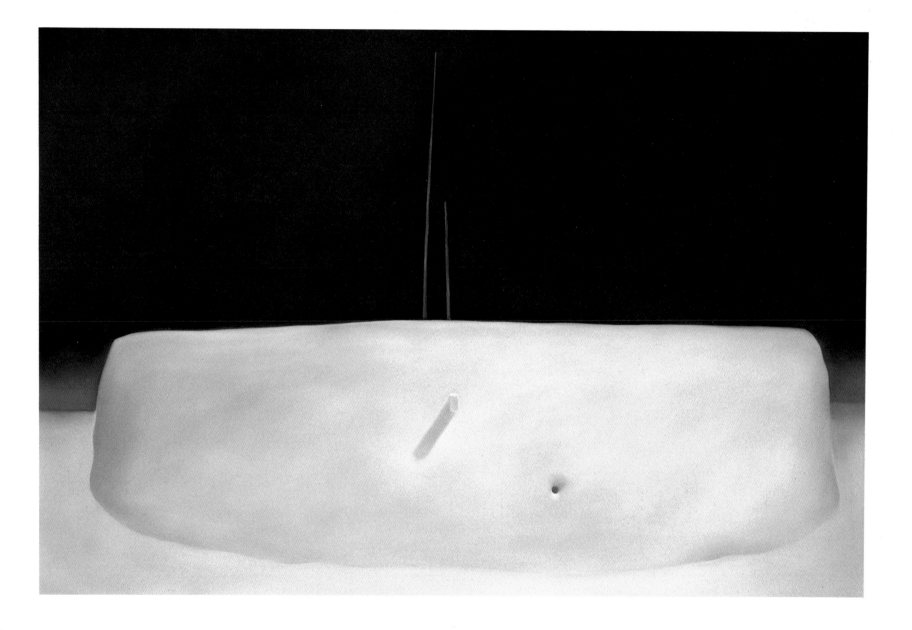

Plate 14

Pecos Shadow (1984)

Oil, 40″ × 40″, Corporate Collection,
Union National Bank and Trust Company

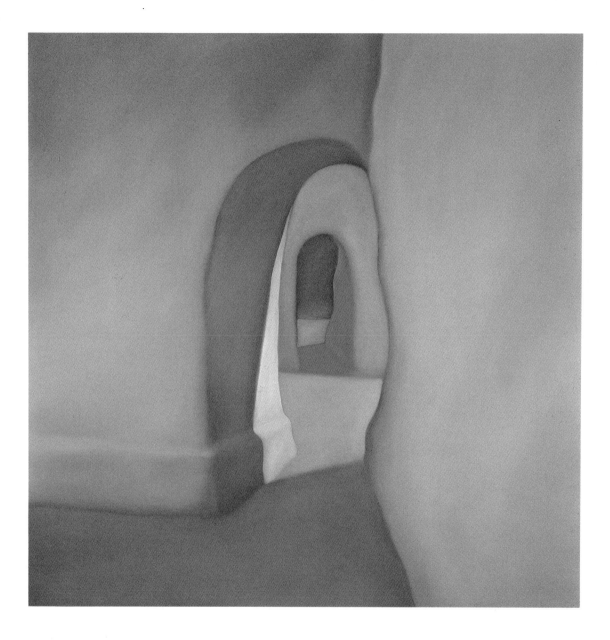

Plate 15

Hacienda Passage (1984)

Oil, 40" × 30", collection of Frank Ribelin

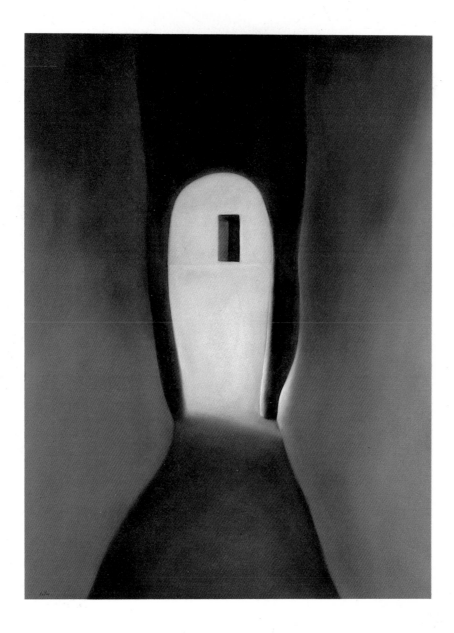

Plate 16

Pecos Dream (1984)

Oil, 40″ × 60″, collection of Dr. and
Mrs. Marvin C. Overton III

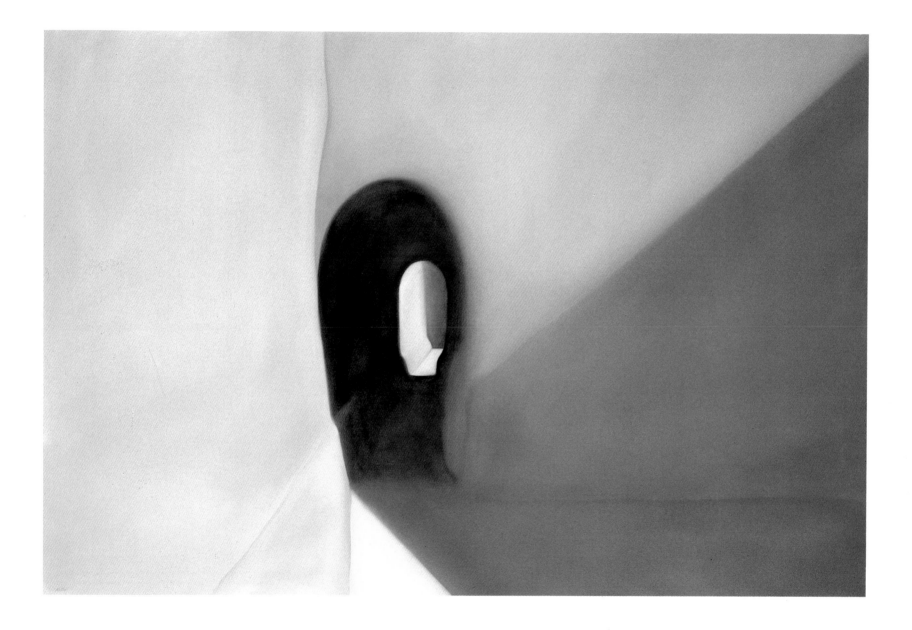

Plate 17

Mountain Barn (1985)

Oil, 30″ × 40″, collection of Dr. and
Mrs. Marvin C. Overton III

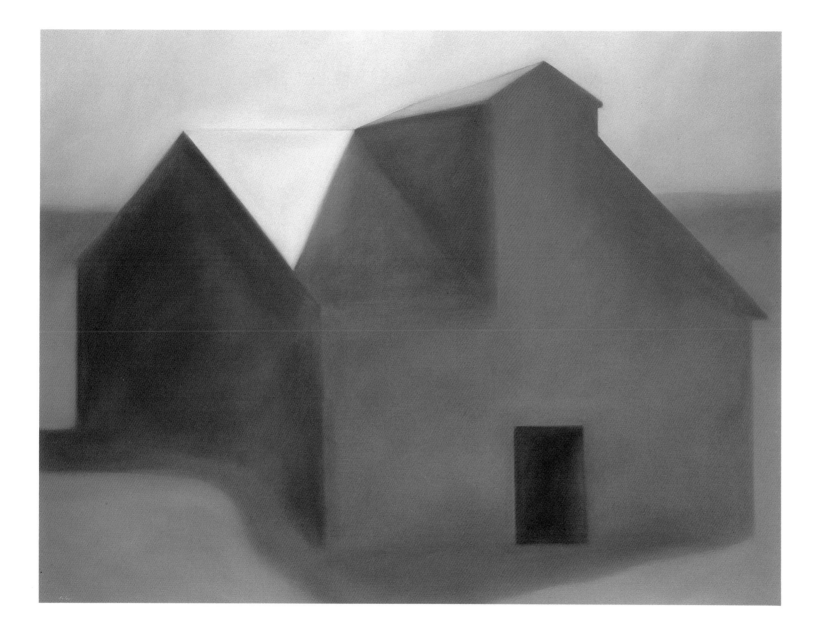

Plate 18

Dawn Dream (1985)

Oil, 20″ × 30″, collection of
Michael Philben

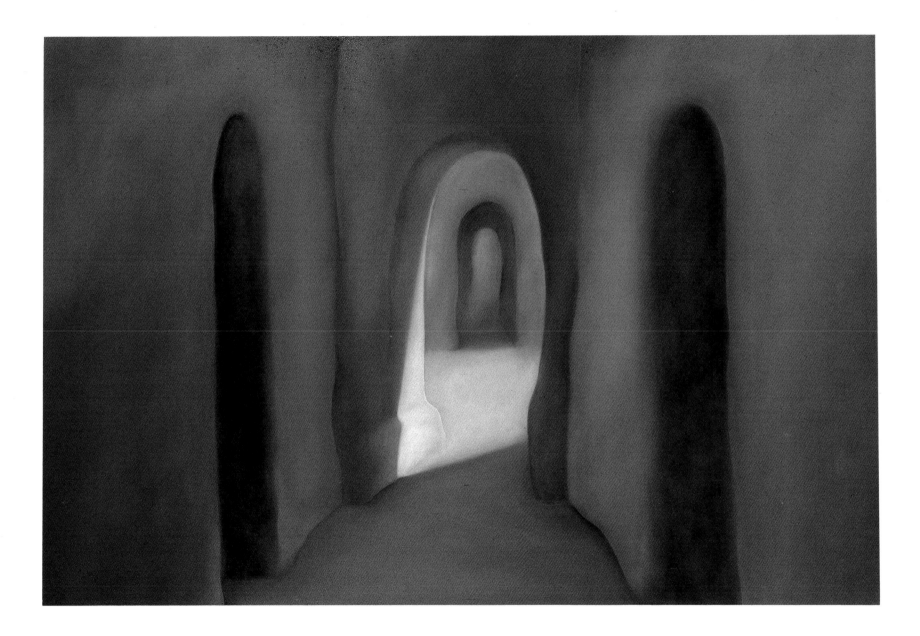

Plate 19

Three Doors (1985)

Oil, 20″ × 30″, collection of Susan
and Richard Hauger

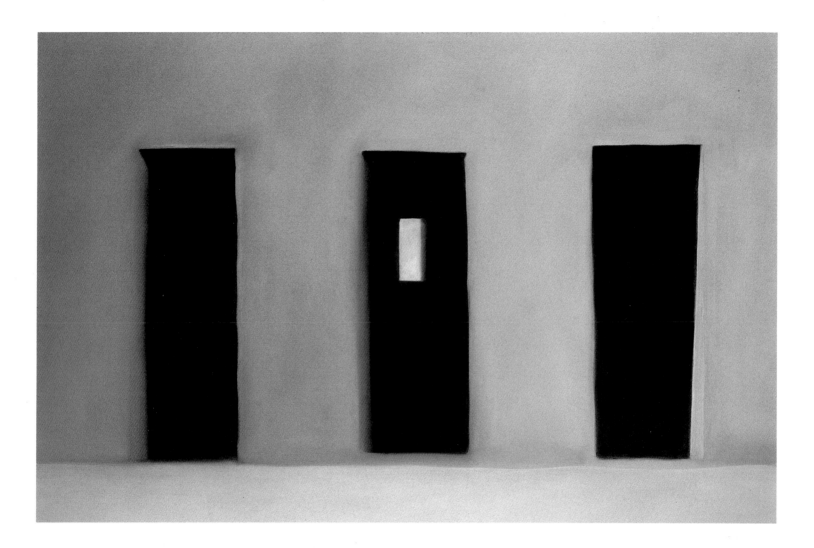

Plate 20

Hacienda Night (1985)

Oil, 30″ × 40″, private collection

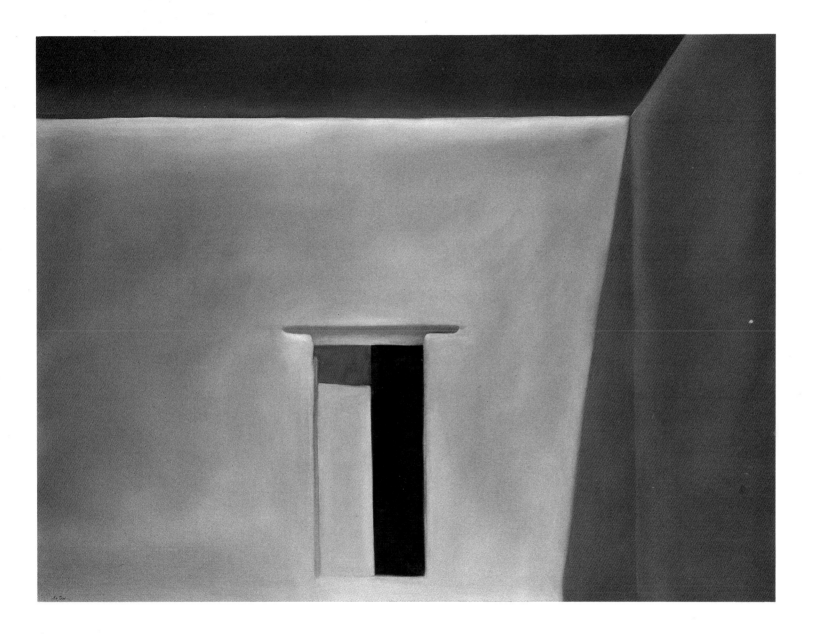

Plate 21

Mission Window (1985)

Oil, 20″ × 40″, collection of
Al and Janie Grove

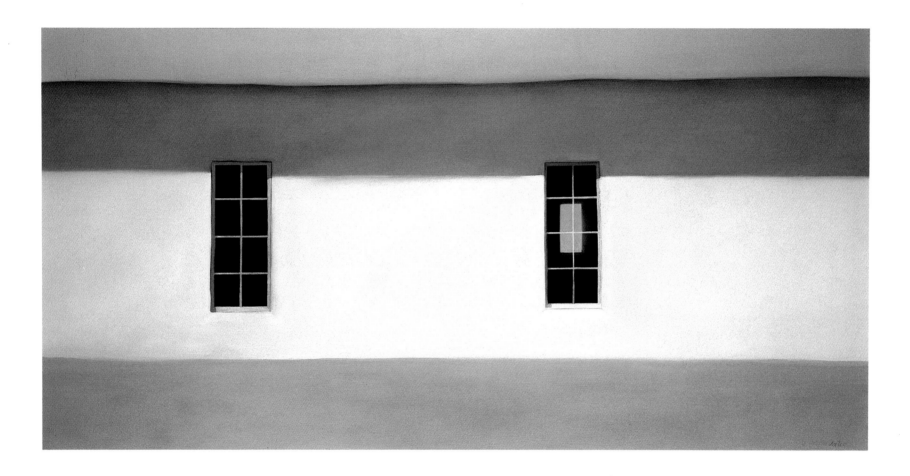

Plate 22

Full Moon (1985)

Oil, 40″ × 60″, ABQ Bank Collection

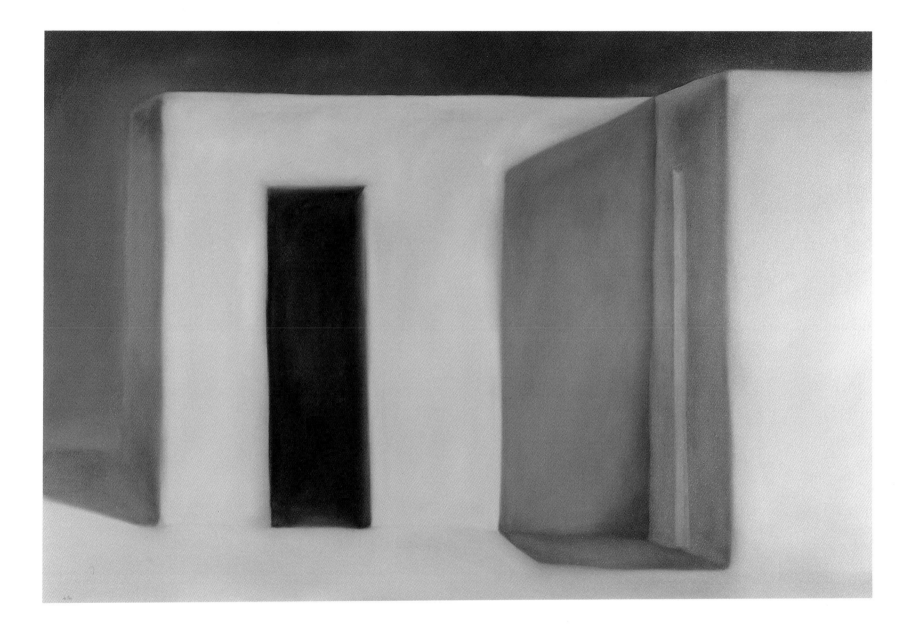

Plate 23

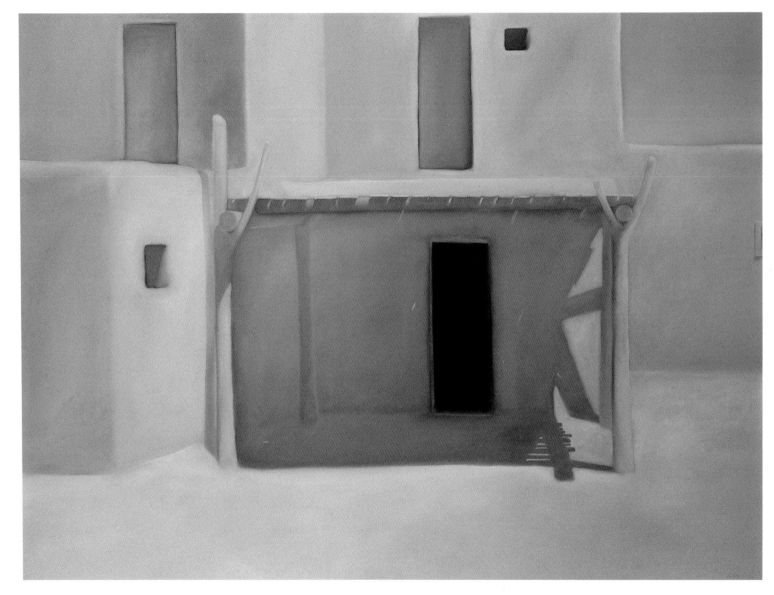

Pinon Fire (1985)

Oil, 30″ × 40″, collection of
William and Patricia Bilinkas

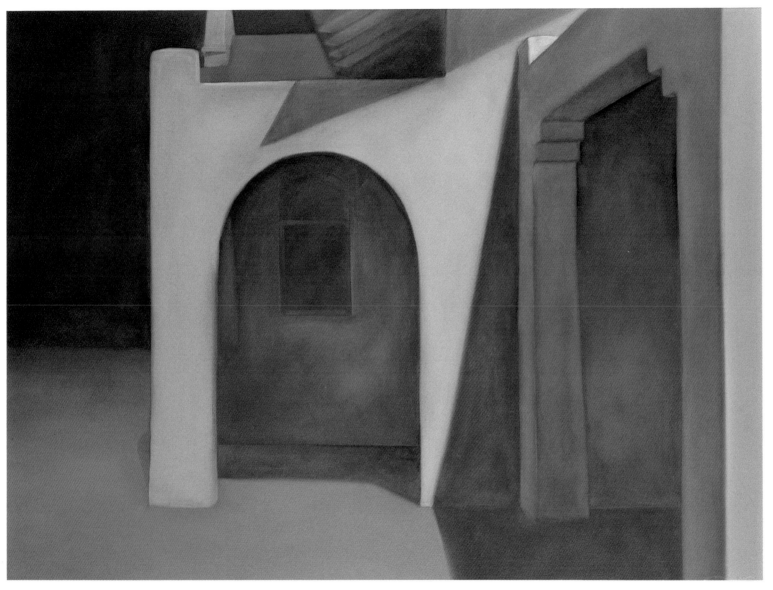

Plate 24

Night Station (1985)

Oil, 30" × 40", collection of Mel E.
and Barbara A. Yost

Plate 25

Picurus Window (1985)

Oil, 30″ × 40″, private collection

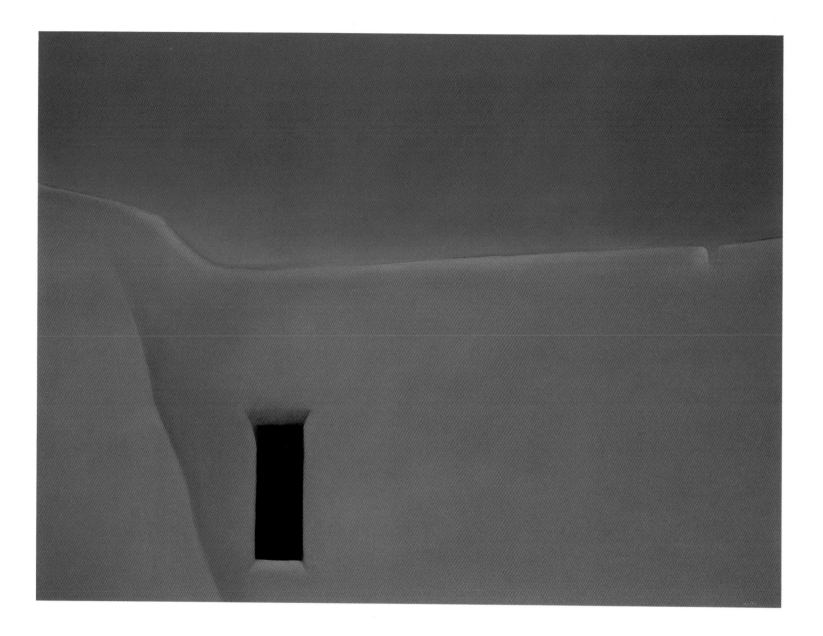

Plate 26

Taos Blanket (1985)

Oil, 20″ × 30″, collection of Mr. and
Mrs. A. J. Vanlandingham

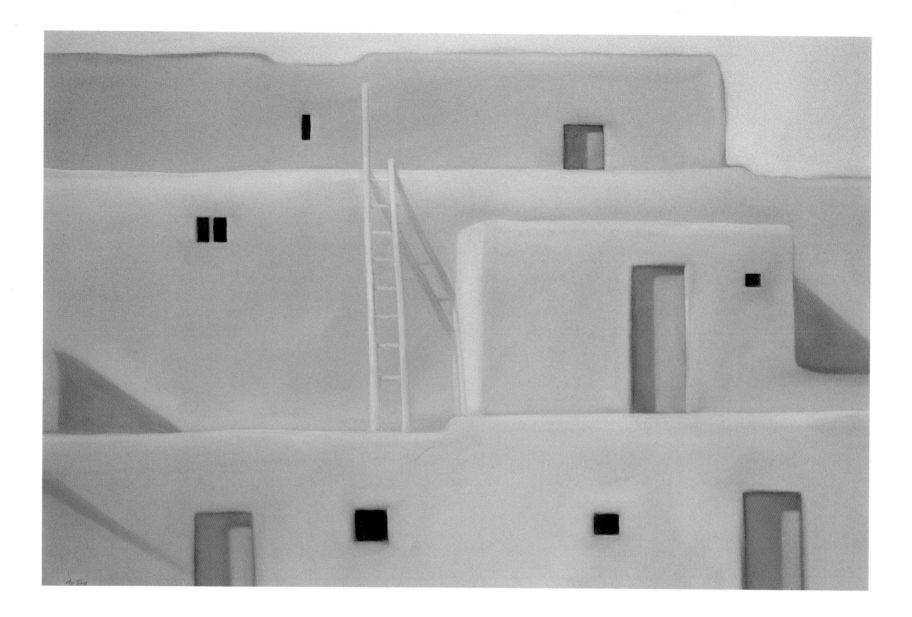

Plate 27

Drum Maker II (1985)

Oil, 30″ × 40″, collection
of Bud Aab

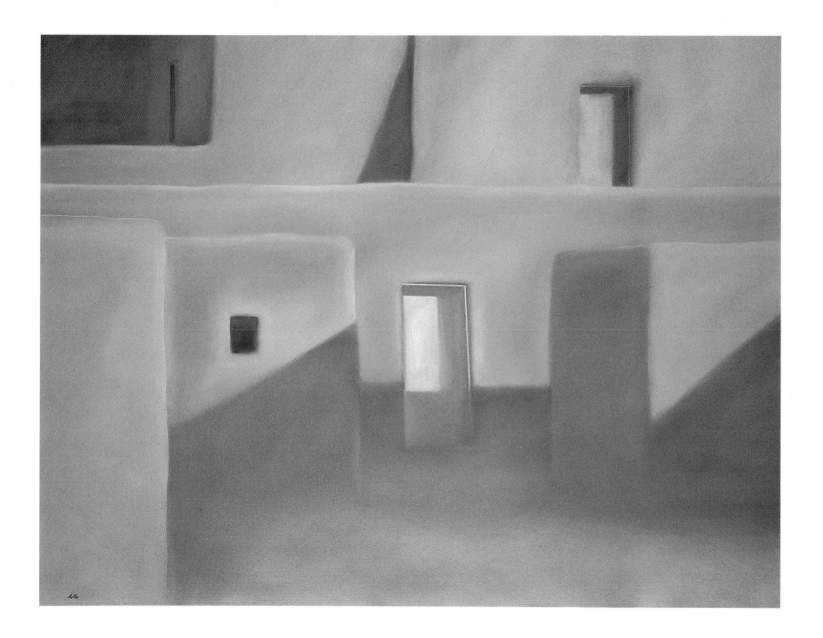

Plate 28

Mountain House (1986)

Oil, 40″ × 60″, collection of Dr. and
Mrs. Marvin C. Overton III

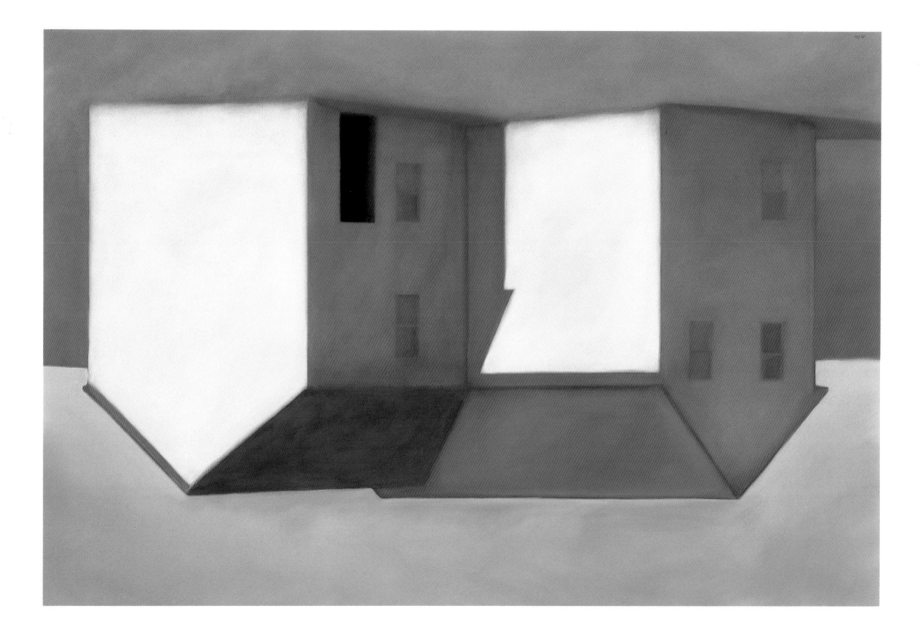

Promise of Dreams (1986)

Oil, 40" × 60", collection of
Carol and Jim Perkins

Plate 29

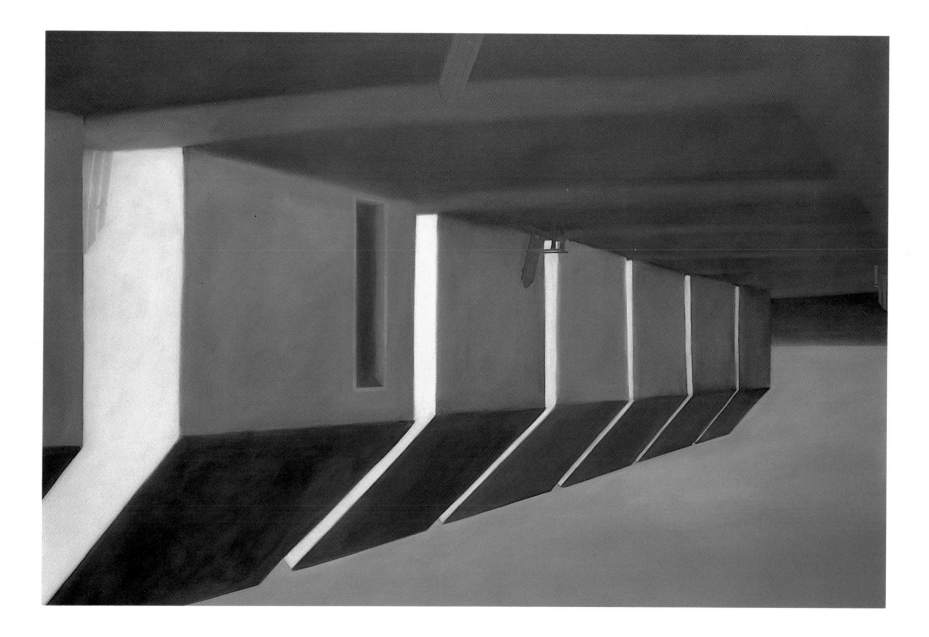

Plate 30

Blue Door Dream (1986)

Oil, 40″ × 30″, collection of Mr. and Mrs. J. R. Pierson, Jr.

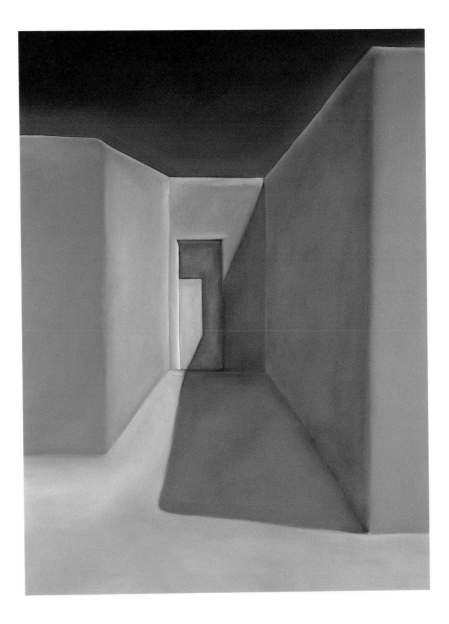

Plate 31

Blue Door (1986)

Oil, 30″ × 40″, collection of Weil,
Gotshal and Manges, Houston

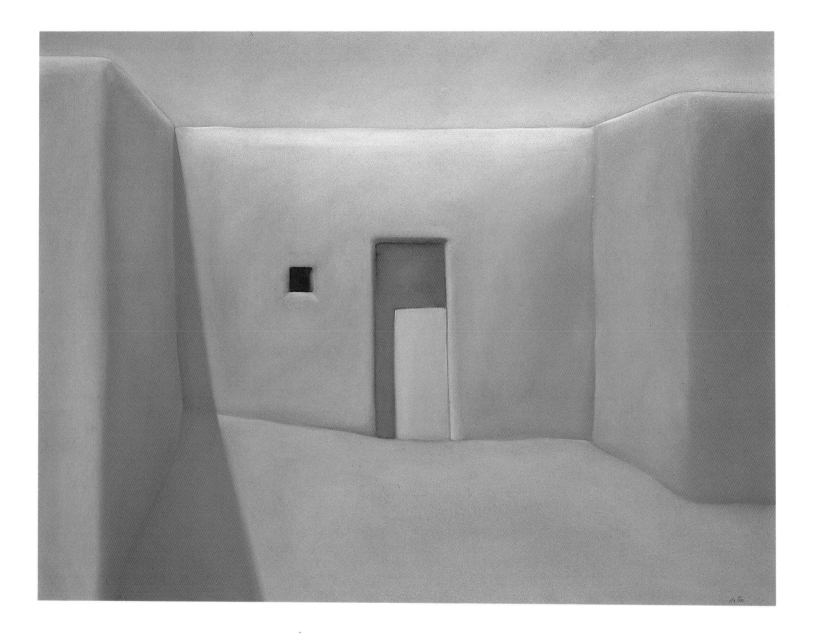

Plate 32

Colorado Barn (1986)

Oil, 40″ × 60″, collection of
Ray and Peggy Bailey

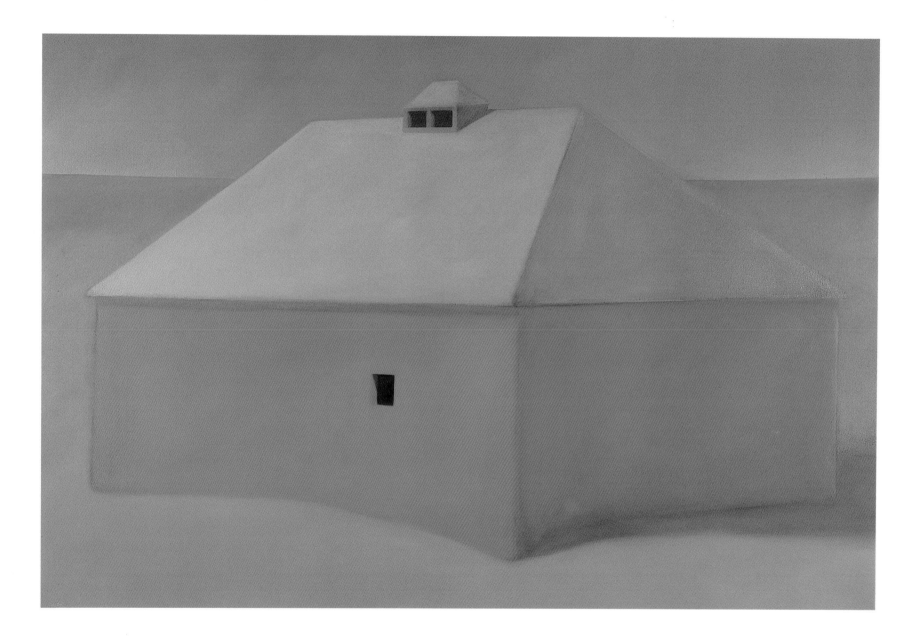

Plate 33

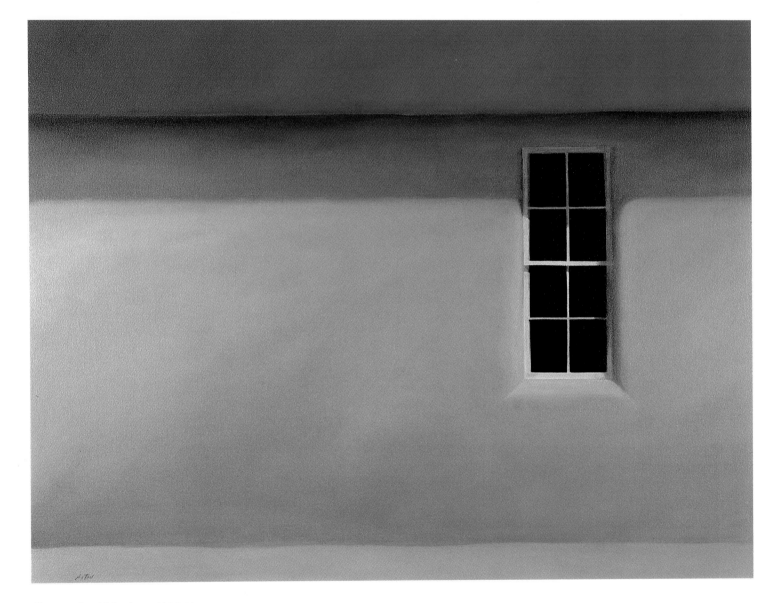

Canoncito Window (1986)

Oil, 30″ × 40″, collection of
James H. Badger, Jr.

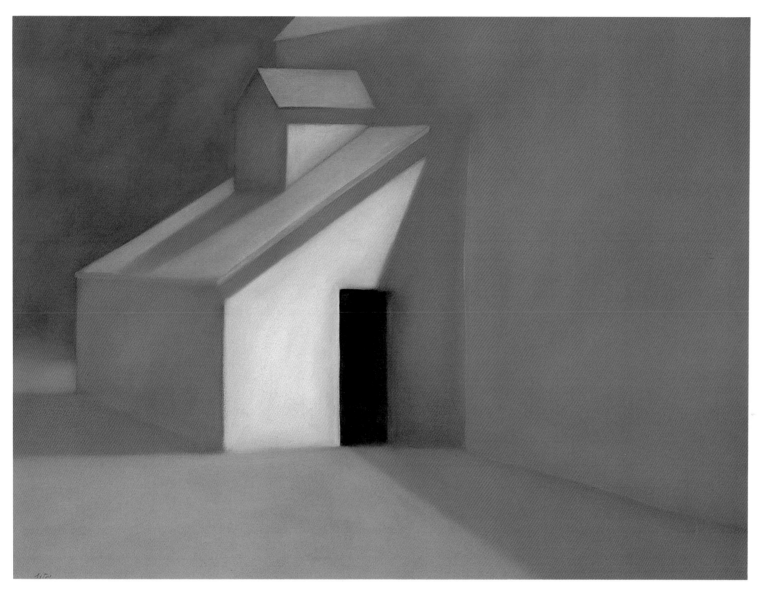

Plate 34

Santuario de Chimayo (1987)

Oil, 30″ × 40″, collection
of Paul Stone

Plate 35

Indian Summer (1987)

Oil, 30″ × 40″, collection of
Dr. H. E. Eugene Bonham

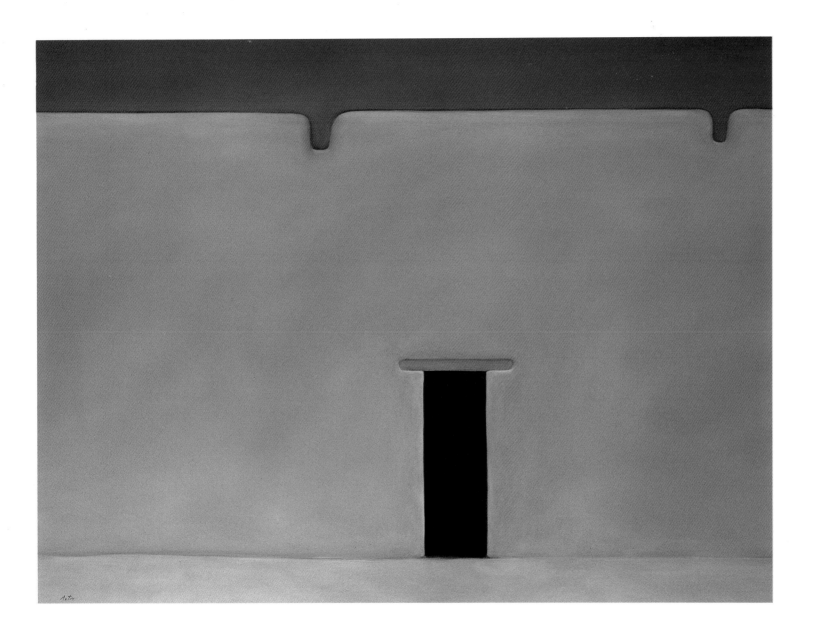

Plate 36

Cape Winds (1987)

Oil, 40″ × 60″, collection of
Thayer and Melani Tutt

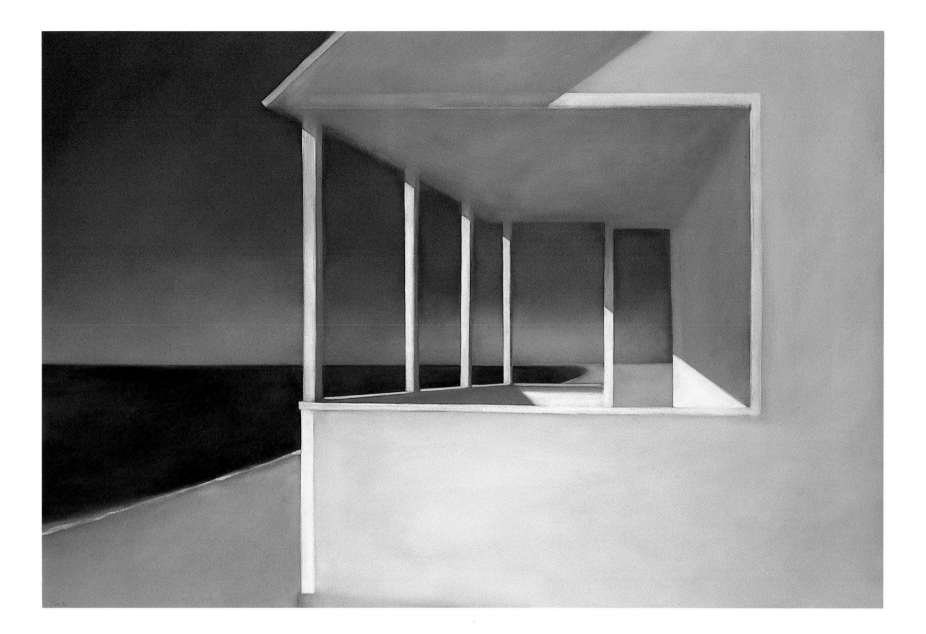

Plate 37

Cape Dunes (1987)

Oil, 30″ × 40″, collection of
Alice and Ed Lusk

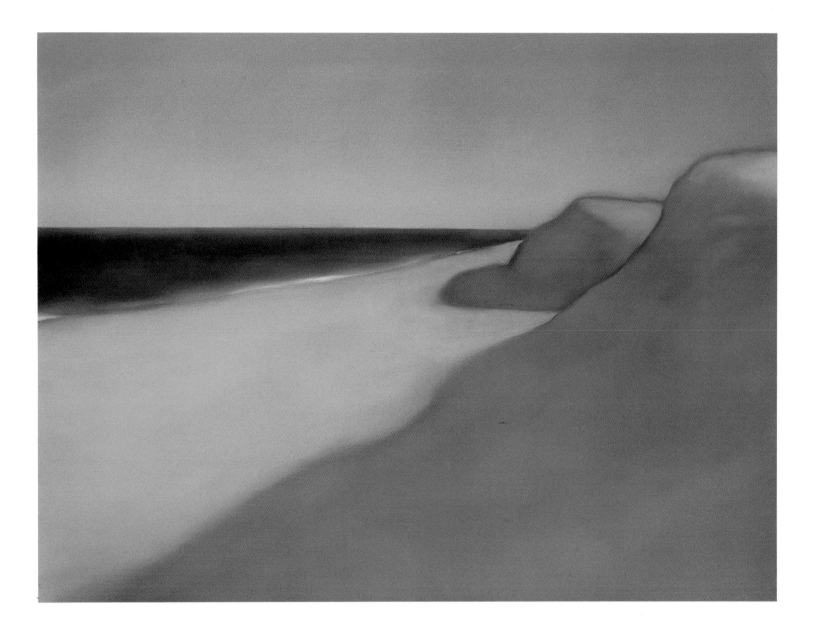

Plate 38

San Ildefonso Sunset (1987)

Oil, 40″ × 60″, collection of
Alice and Ed Lusk

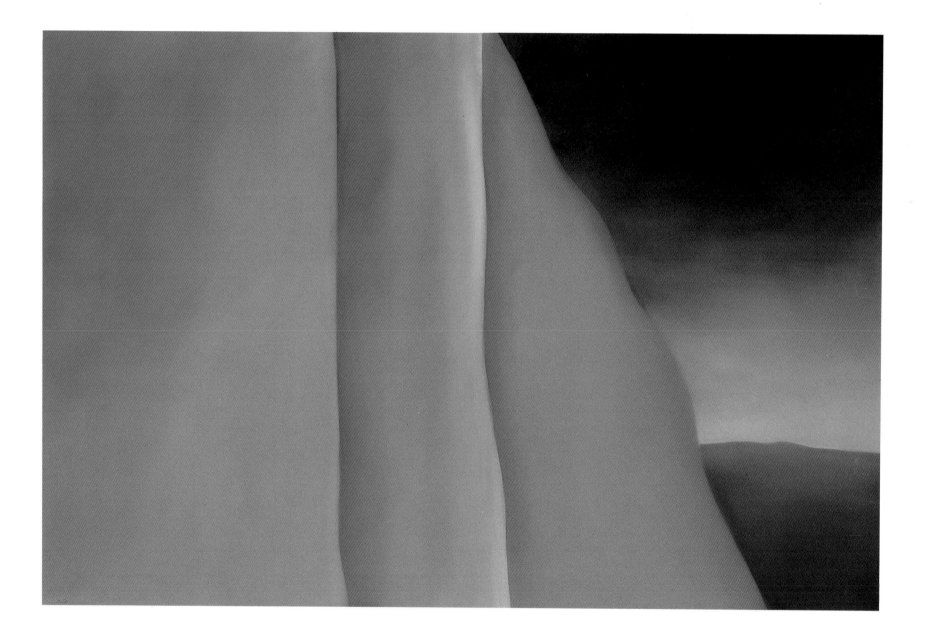

Plate 39

Cape Houses (1987)

Oil, 30″ × 40″, collection of
Alice and Ed Lusk

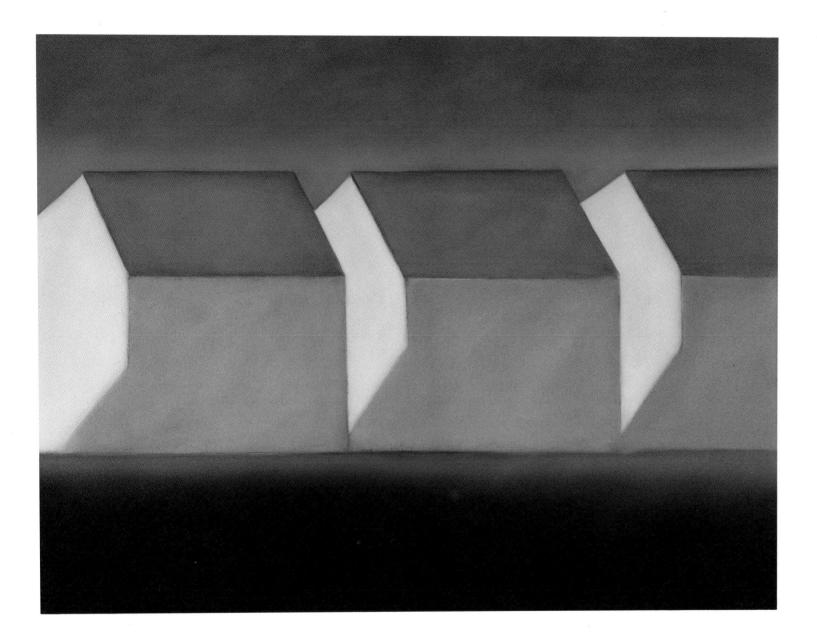

Plate 40

Summer House (1987)

Oil, 20″ × 30″, collection of
Helen Behrmann

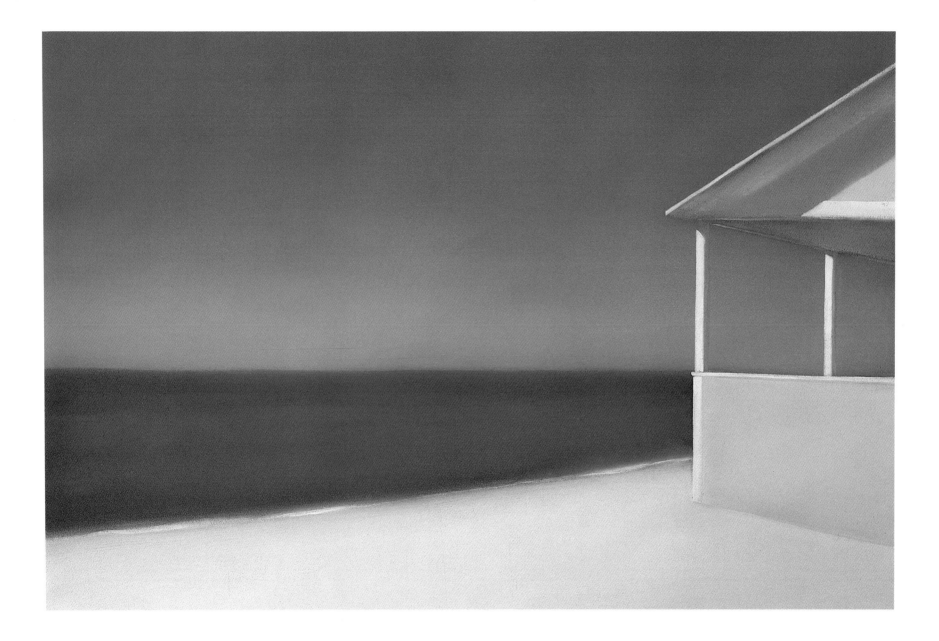

Plate 41

House on Monhegan Island (1987)

Oil, 30" × 40", private collection

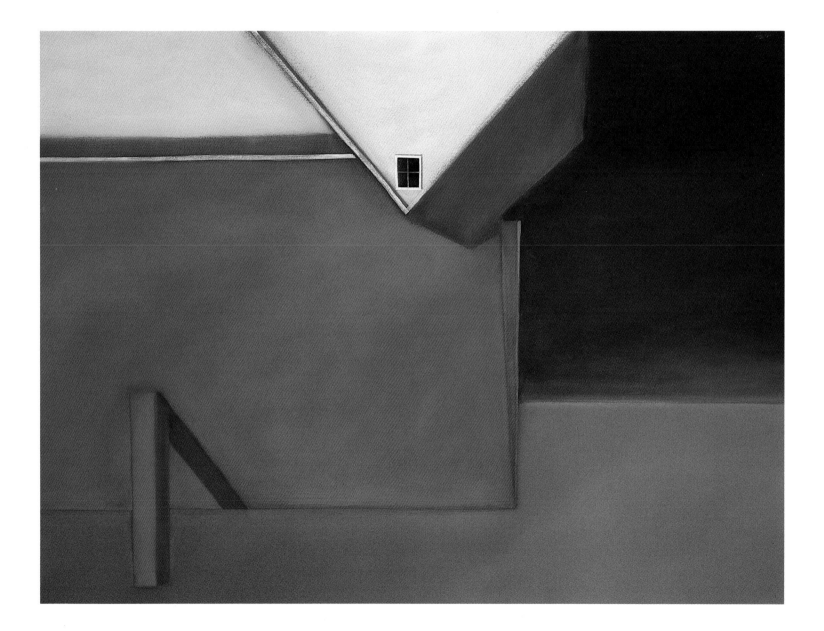

Plate 42

Tewa Blue (1987)

Oil, 20″ × 30″, private collection

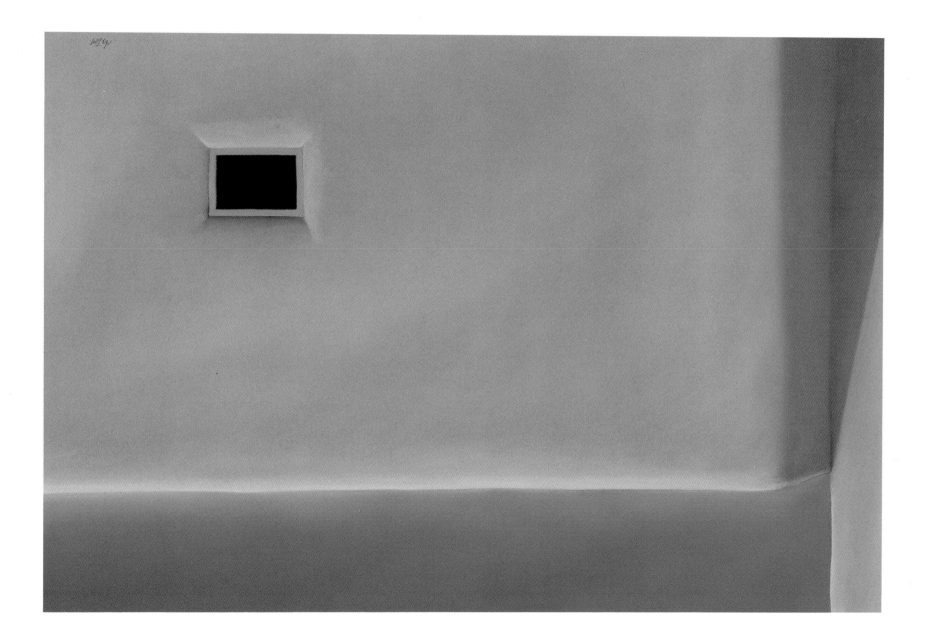

Plate 43

Taos Rose (1987)

Oil, 30" × 40", collection of
Claud and Thelma Baruch

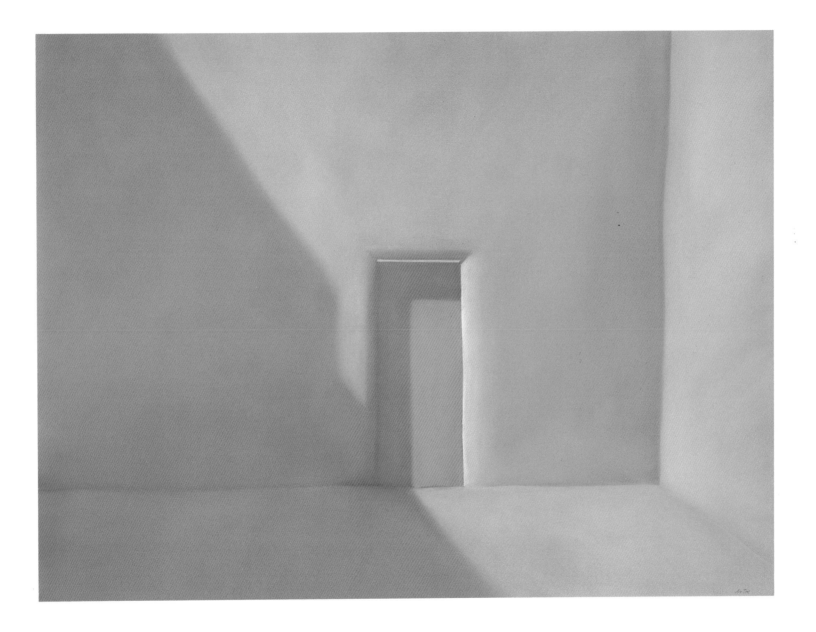

Plate 44

Mountain Santos (1987)

Oil, 20″ × 30″, collection of
Sandy Markley

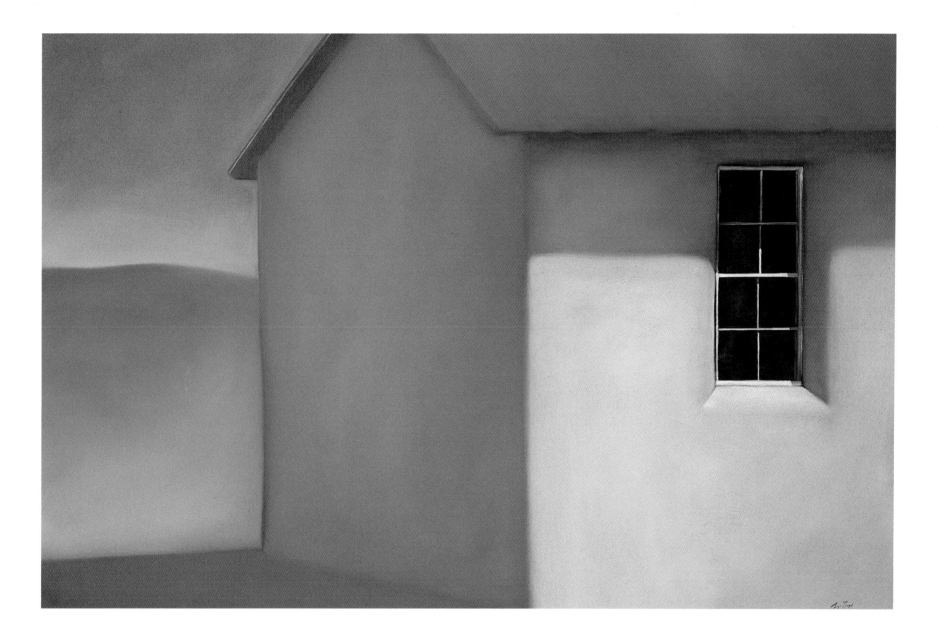

Plate 45

Morning Drums (1987)

Oil, 60″ × 40″, collection of Maxine
and Leslie Fisher

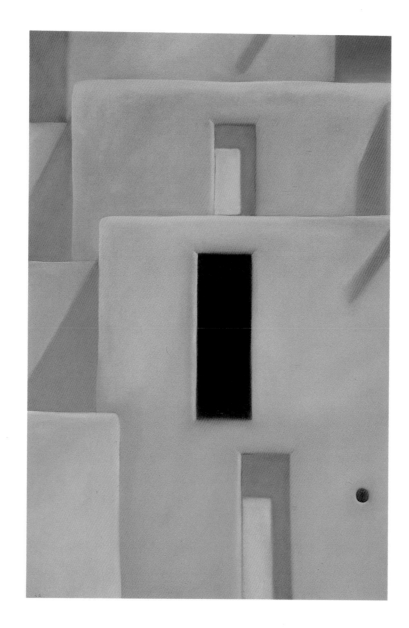

Plate 46

Pueblo Turquoise (1987)

Oil, 30″ × 40″, collection of
William and Patricia Bilinkas

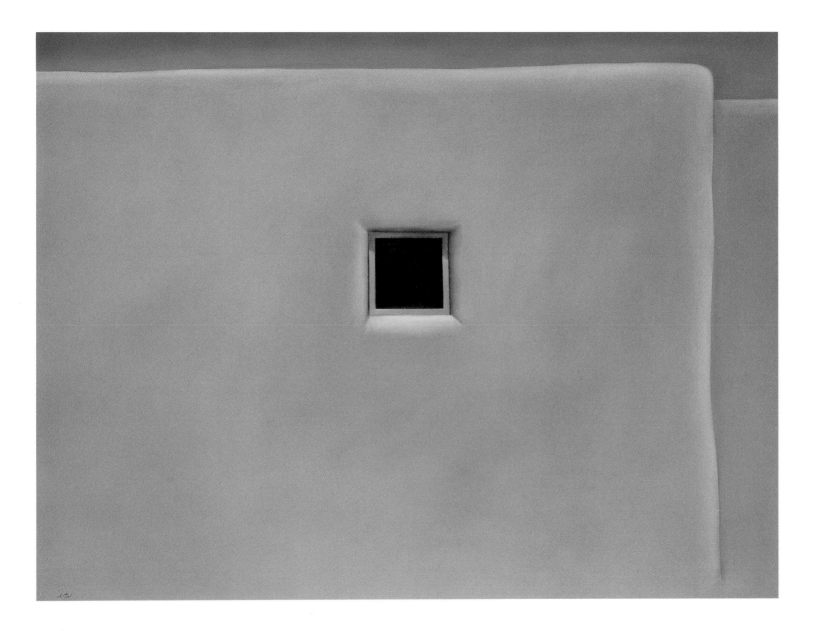

Plate 47

San Geronimo Days (1987)

Oil, 20″ × 30″, collection of
Wendell and Arlene Haley

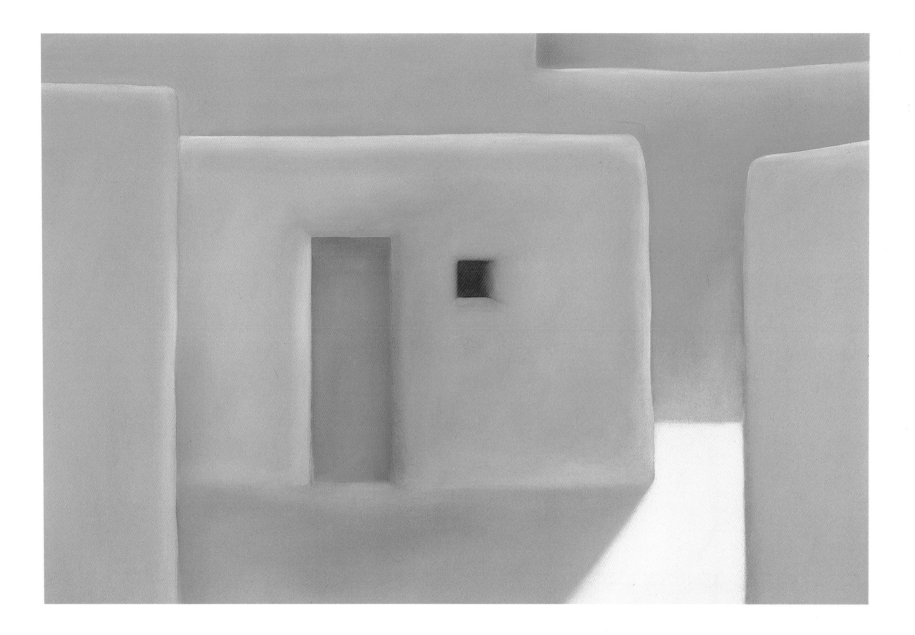

Plate 48

Equus Dream (1987)

Oil, 30″ × 40″, collection of Thayer
and Melani Tutt

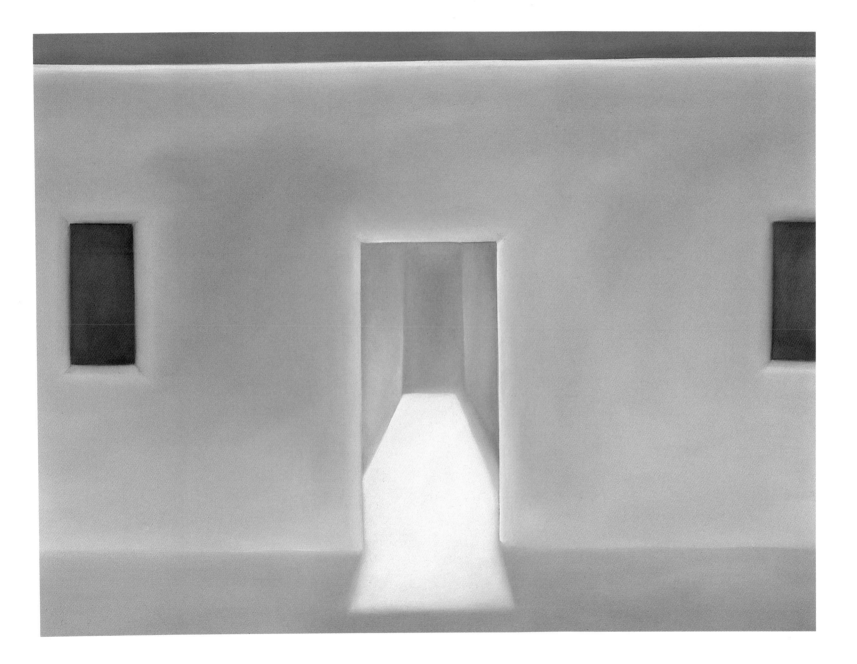

JOHN AXTON

John Axton "Adobe Winds" Oil 30" x 40"

Photo: Herb Lotz

Plate 49

Ranchos de Taos (1987)

Oil, 40" × 30", collection of
Sue Bryant

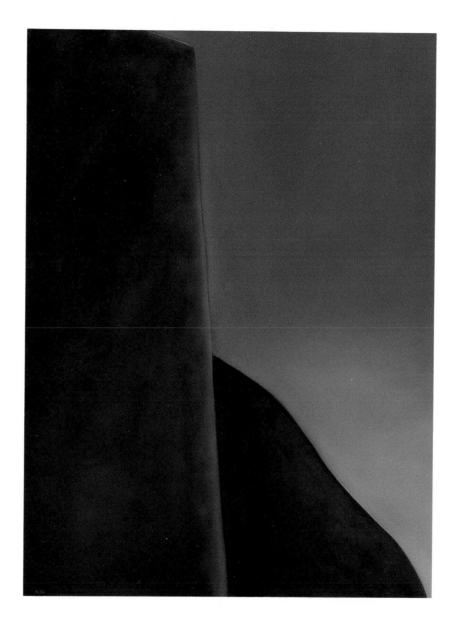

Plate 50

Sea Dream (1987)

Oil, 40″ × 60″, collection of
Ventana Fine Art

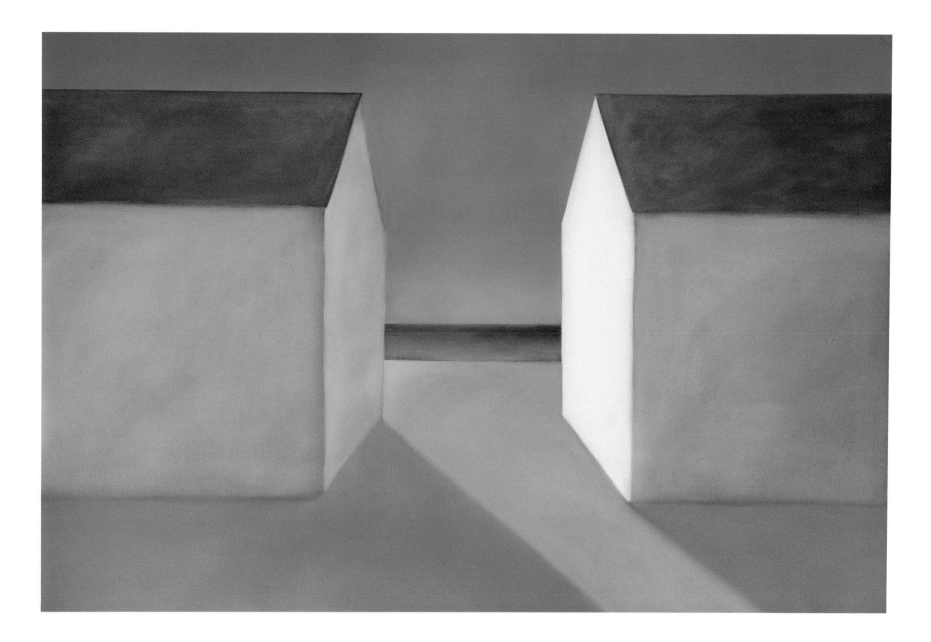

Plate 51

Cape Shadows (1987)

Oil, 20″ × 40″, collection of Mr. and
Mrs. John T. Schwieters

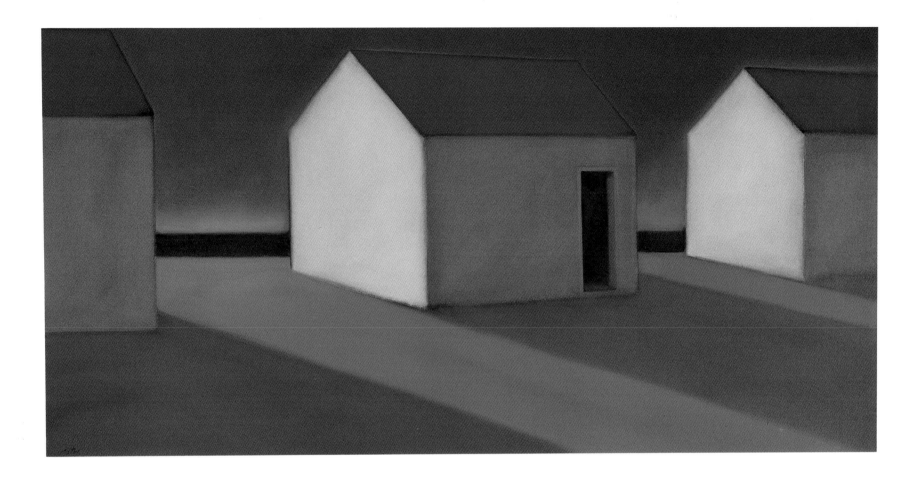

Plate 52

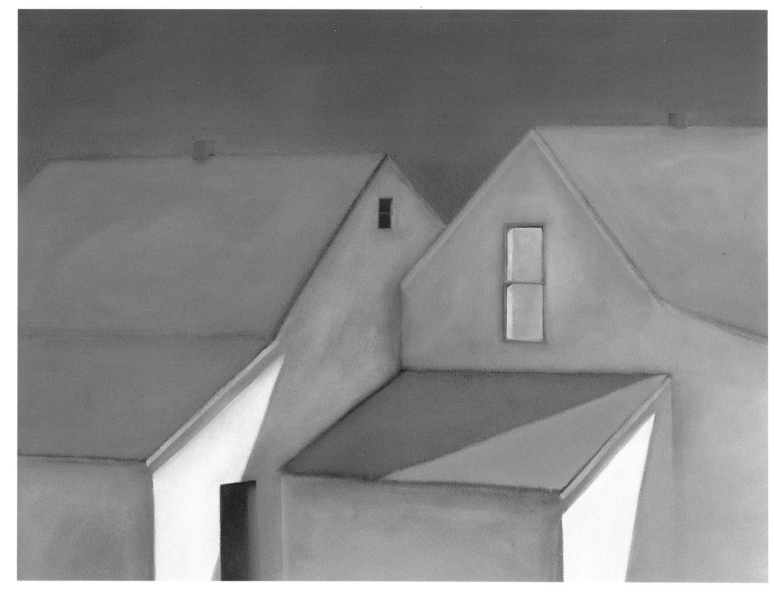

Dreamers (1987)

Oil, 30″ × 40″, collection of Dr. and
Mrs. Walter J. Meyer III

Plate 53

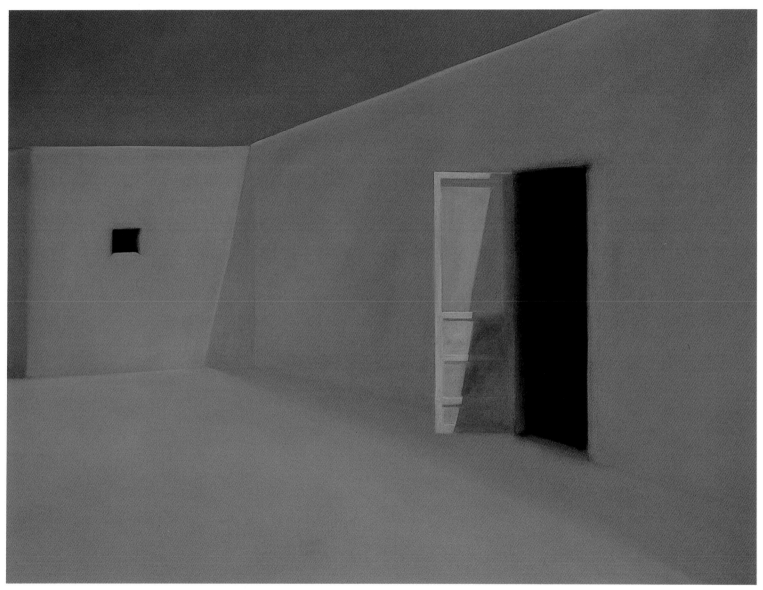

Summer Doors (1987)

Oil, 30″ × 40″, collection of
Jane Aoyagi

Plate 54

Pueblo Shadow II (1987)

Oil, 30″ × 40″, collection of Morris
D. and Dona J. Kemper

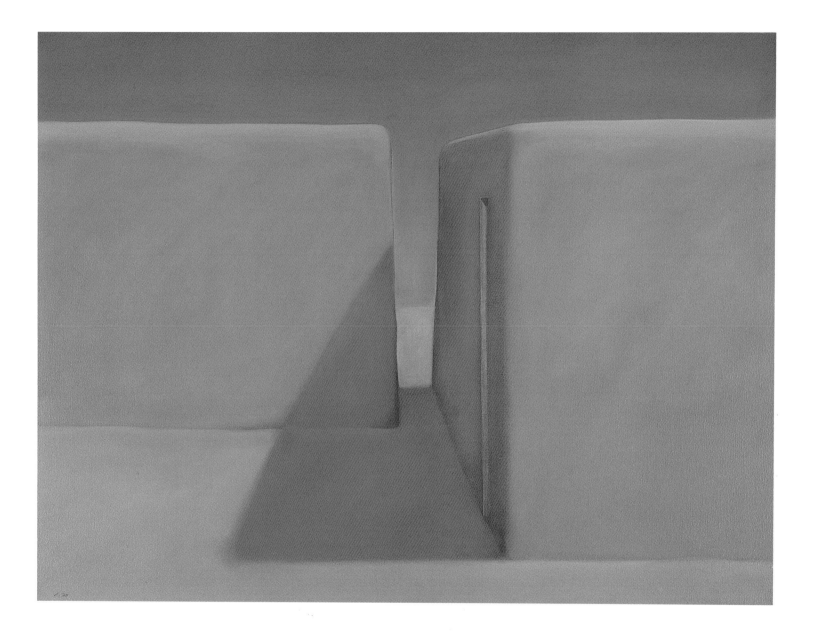

Plate 55

Rancho de Taos Church II (1987)

Oil, 18″ × 12″, collection of Mickey
and Patrick Rice

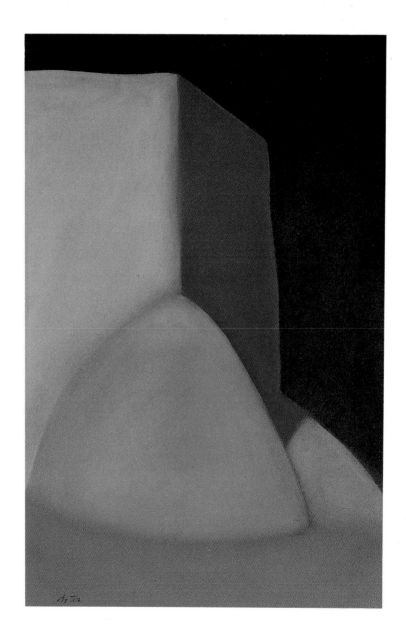

Plate 56

Ranchos Sun (1987)

Oil, 18″ × 12″, collection of
Michael Murray

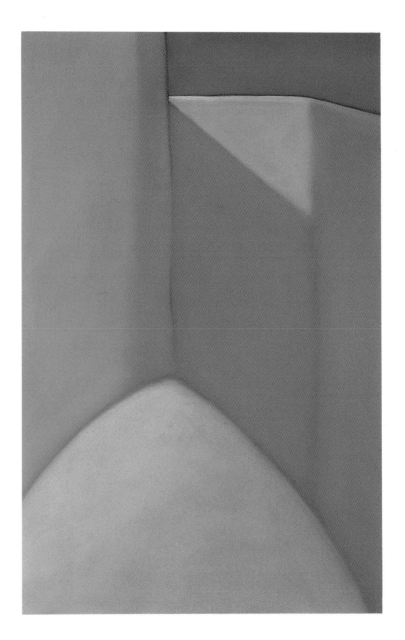

Plate 57

Independence Day (1988)

Oil, 30″ × 40″, collection of
Dr. H. E. Eugene Bonham

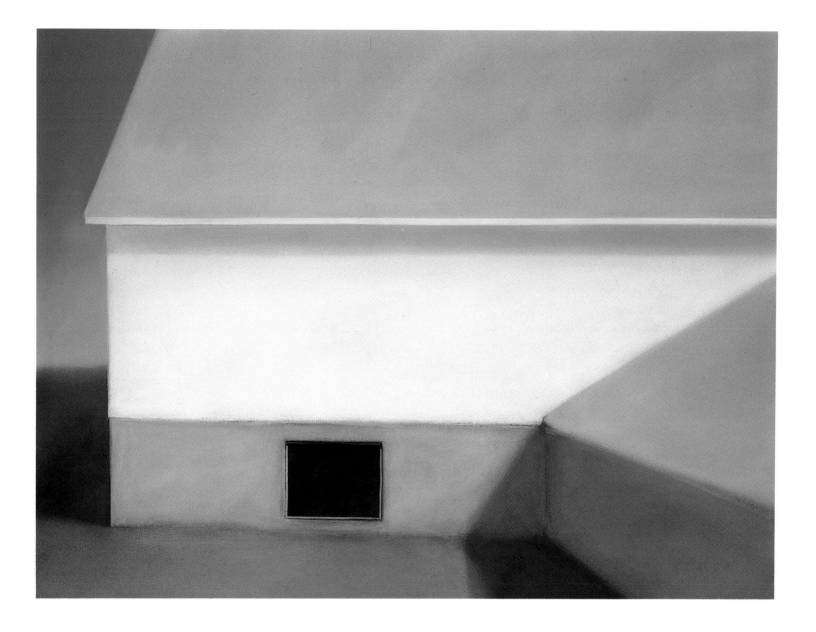

Plate 58

Los Golondrinas (1988)

Oil, 30″ × 20″, collection of
Dr. and Mrs. Michael D. Cosgrove

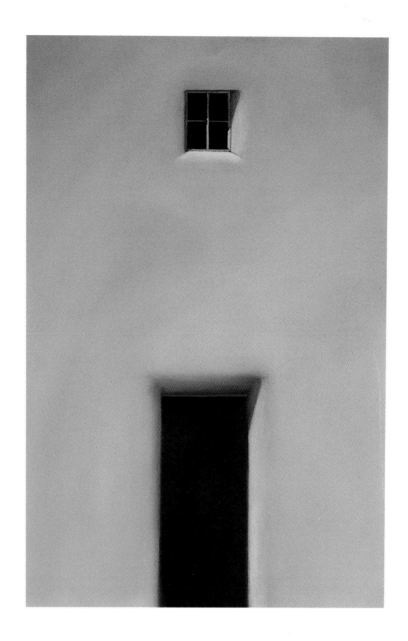

Plate 59

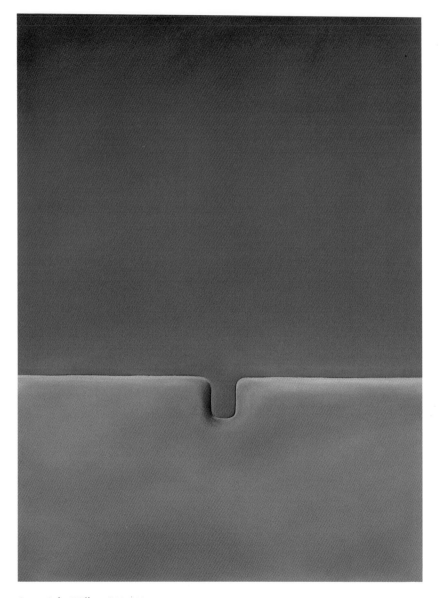

Spanish Rifles (1988)

Oil, 40″ × 30″, collection of
Kathleen McRee

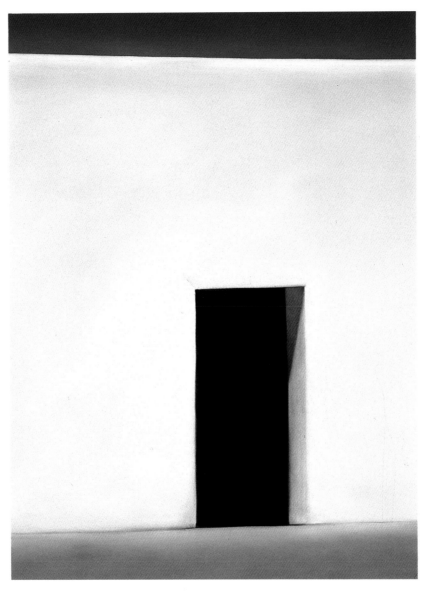

Plate 60

Desert Stones (1988)

Oil, 40″ × 30″, collection of Dr. and
Mrs. William Stennis

Plate 61

Summer Shadows (1988)

Oil, 20″ × 30″, collection of
Carl and Janice Crow

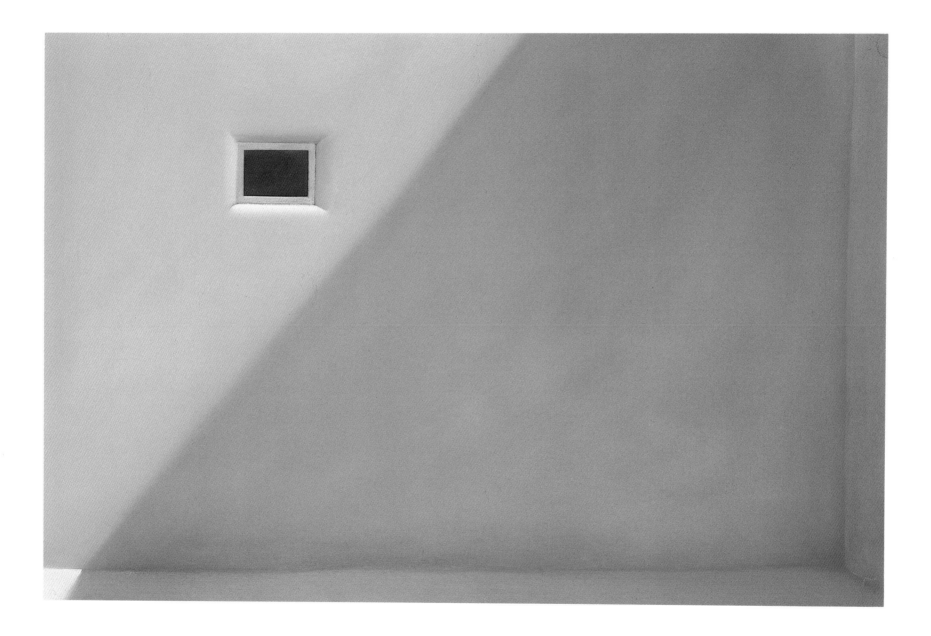

Plate 62

Spirit Song (1988)

Oil, 40" × 60", collection of Philip
and Ellen Glass

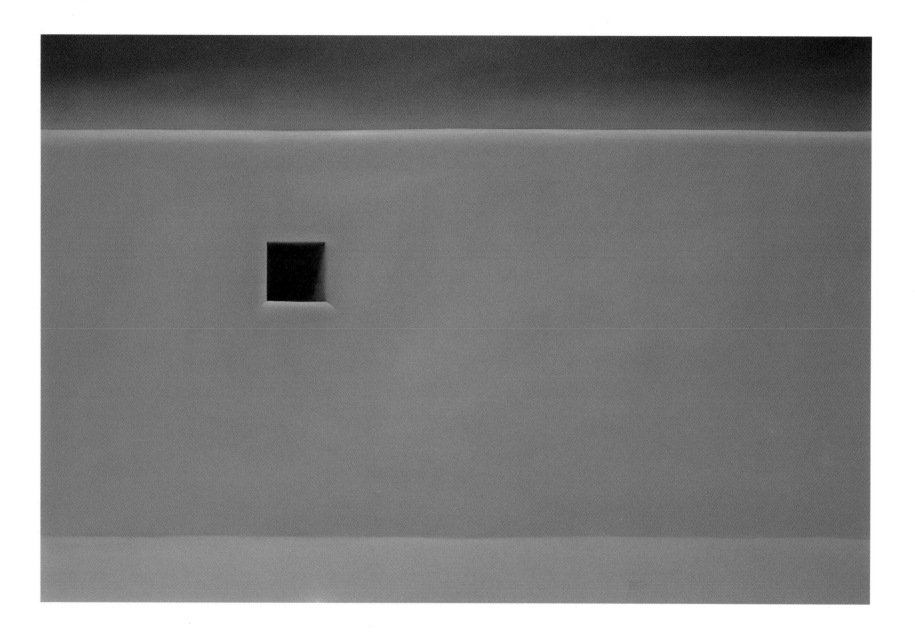

Plate 63

Sacred Walls

1978, lithograph, 22″ × 30″
(Publisher, David "Apple" Baker;
Lithographer, Bud Shark)

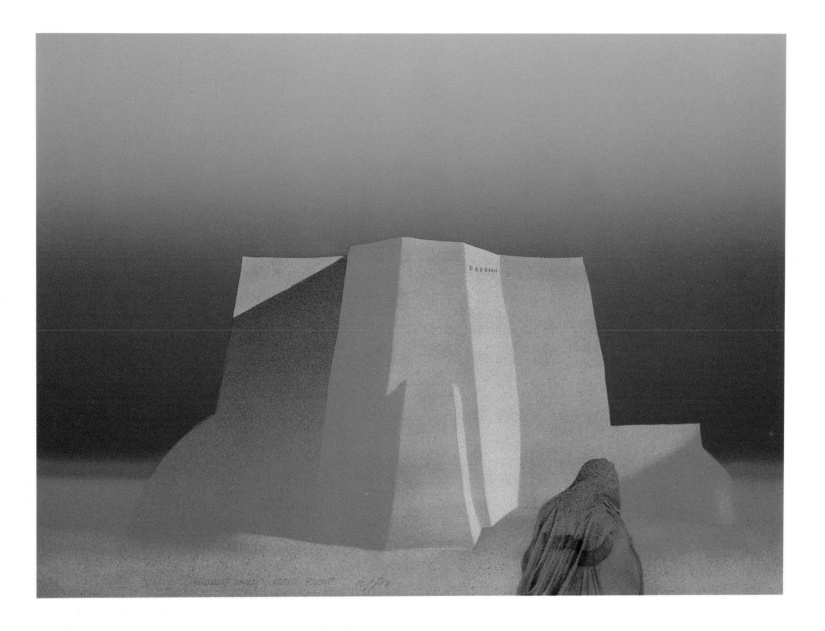

Plate 64

American Shadows

1978, lithograph, 22″ × 22″
(Publisher, David "Apple" Baker;
Lithographer, Bud Shark)

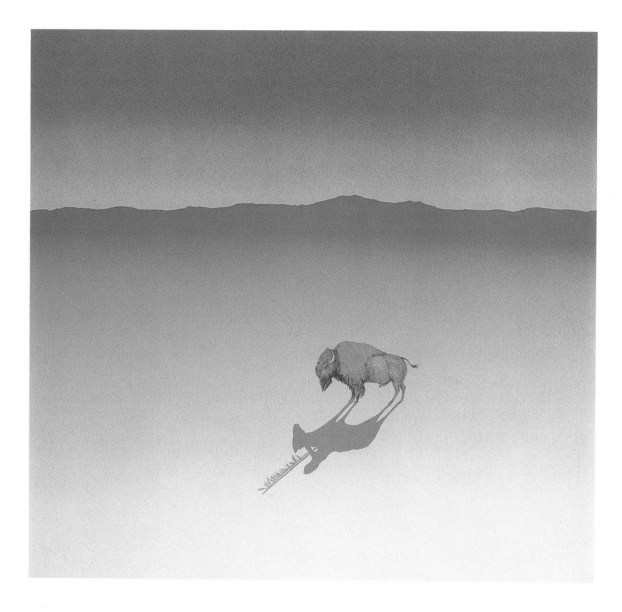

Plate 65

Las Trampas

1979, lithograph, 22″ × 30″
(Publisher, David "Apple" Baker;
lithographer, Bud Shark)

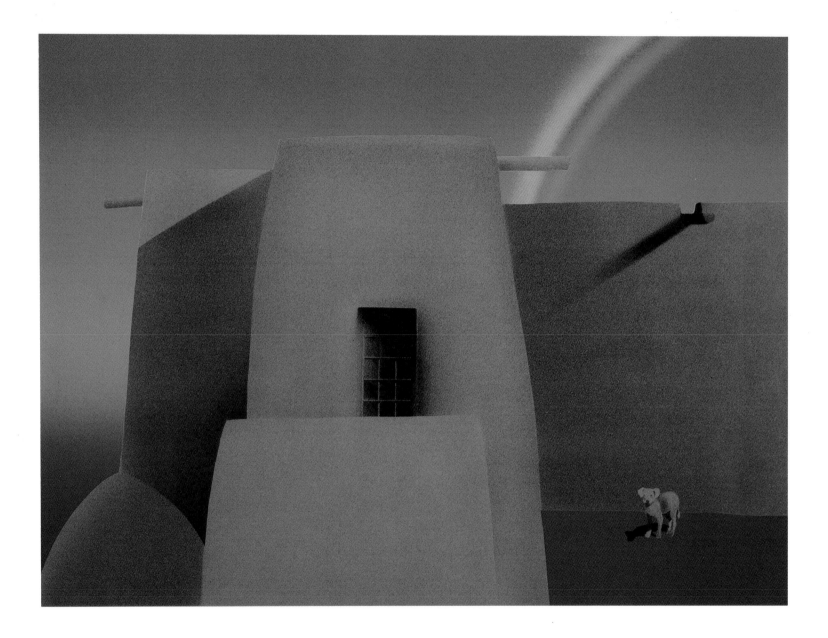

Plate 66

Wyoming Surrender

1981, lithograph, 30″ × 30″
(Publisher, Breckenridge Galleries;
Lithographer, Bud Shark)

INDEX TO ADVERTISERS

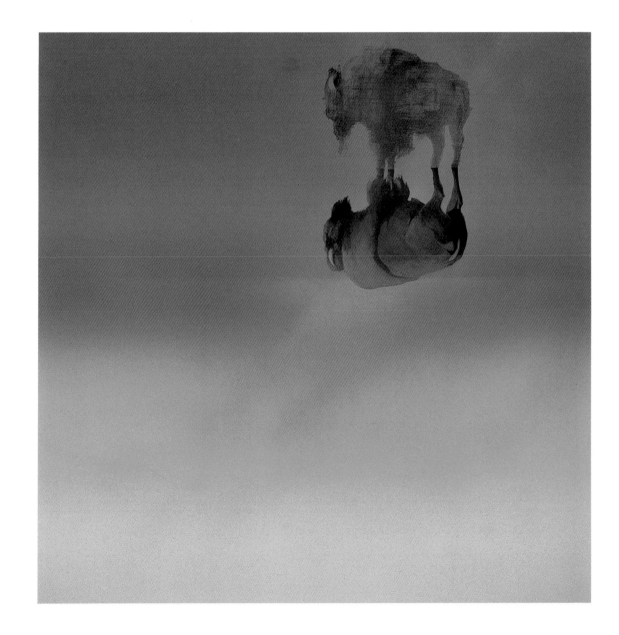

Plate 67

Taos Dream

1981, lithograph, 22" × 30"
(Publisher, Enthios Gallery;
Lithographer, Southwest Graphics)

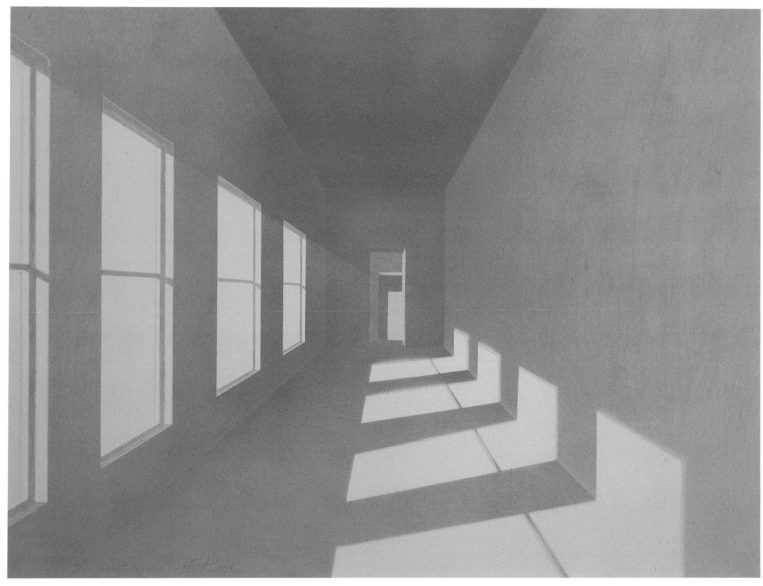

Plate 68

Silent Passage

1983, lithograph, 22″ × 30″
(Publisher, John Szoke Graphics, NYC;
Lithographer, Bud Shark)

Plate 69

Boundary Line

1984, lithograph, 30″ × 40″
(Publisher, John Szoke Graphics, NYC;
Lithographer, Bud Shark)

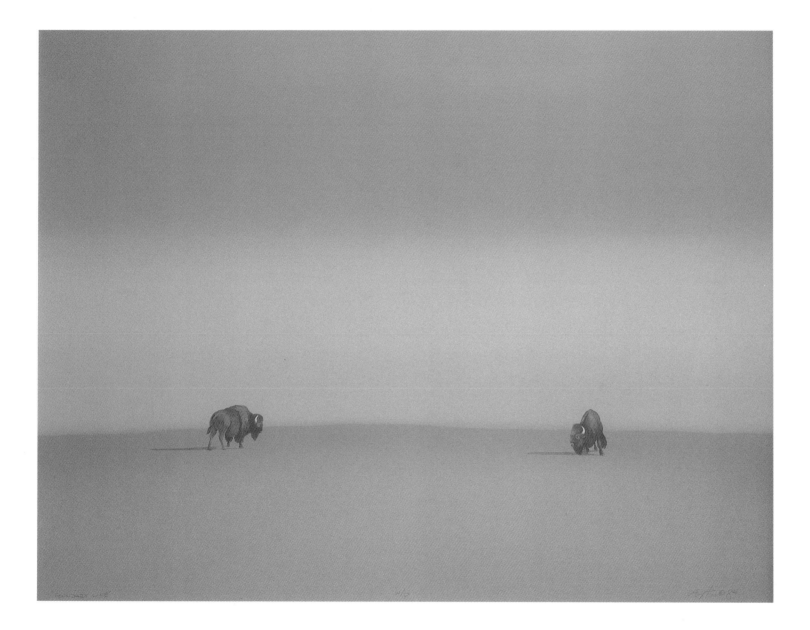

Plate 70

San Miguel

1987, lithograph, 30″ × 40″
(Publisher, John Szoke Graphics, NYC;
Lithographer, Robert Arber)

Ventana

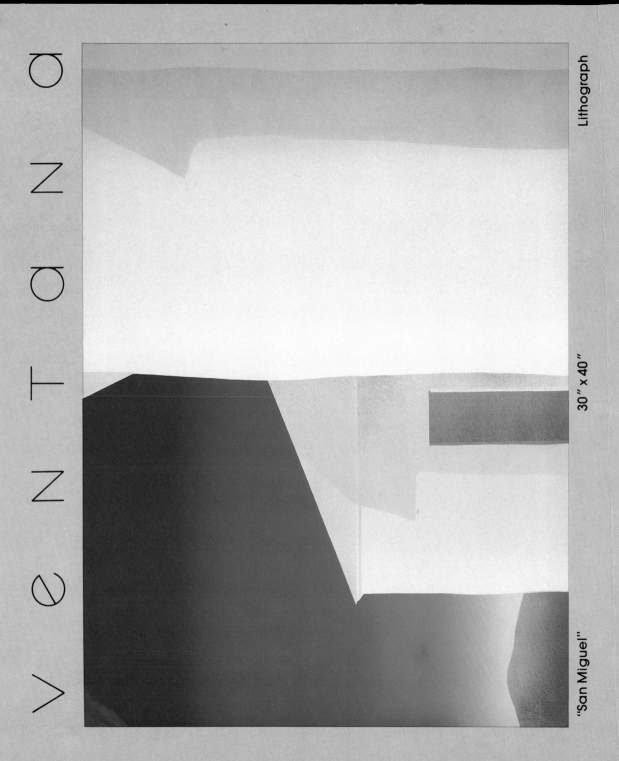

"San Miguel"

30" x 40"

Lithograph

JOHN AXTON
One Man Show: Friday, June 26, 1987

VENTANA FINE ART
Inn at Loretto • 211 Old Santa Fe Trail
Santa Fe, New Mexico 87501 505-983-8815

"LA PLAYA" OIL ON BOARD 12 x 16

GINER BUENO

Linda McAdoo Galleries, Ltd.

503 Canyon Road
Santa Fe, New Mexico 87501
505•983•8900

"*Poetry in Light and Color*"

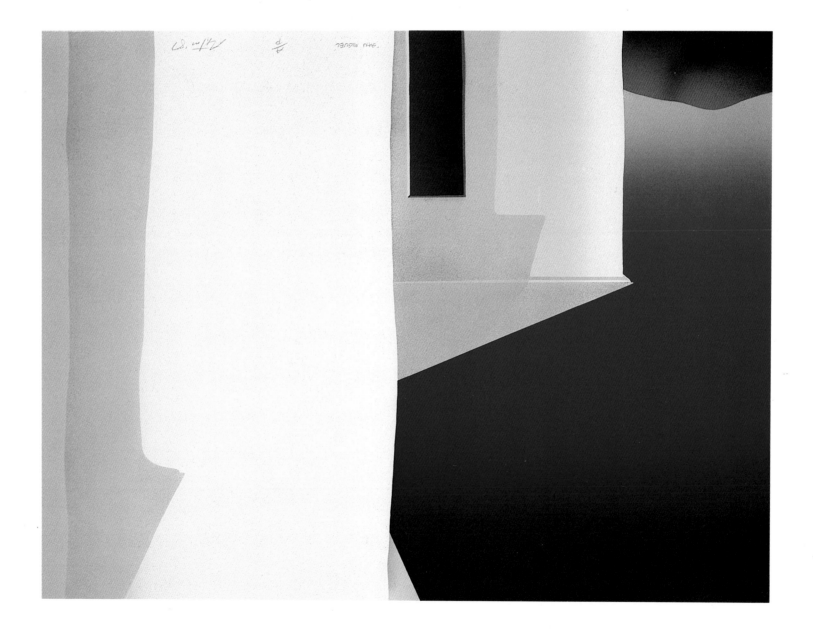